Dinners
&
Nightmares

By Diane Di Prima

Foreword By Robert Creeley

Last Gasp
San Francisco

Dinners & Nightmares
© 2003 Diane di Prima

Published and Distributed by
Last Gasp of San Francisco
777 Florida Street
San Francisco, CA 94110
www.lastgasp.com
email: gasp@lastgasp.com

ISBN 0-86719-395-6
First Printing 1998
Second Printing 2003
Printed in Hong Kong

Cover Design by Tara Marlowe
Photo of Author by James Oliver Mitchell
Photo of New Bowery Theatre by Peter Moore
Book Design by James Stark

San Francisco

Books by Diane di Prima

This Kind of Bird Flies Backward
Dinners and Nightmares
The New Handbook of Heaven
Poets' Vaudeville
Seven Love Poems from the Middle Latin
Haiku
New Mexico Poem
Earthsong: Poems 1957-1959
Hotel Albert
Memoirs of a Beatnik
L.A. Odyssey
The Book of Hours
Kerhonksen Journal
Revolutionary Letters
The Calculus of Variation
Freddie Poems
Selected Poems: 1956-1976
Loba: Book One
Wyoming Series
The Mysteries of Vision
Pieces of a Song
Seminary Poems
The Mask is the Path of the Star
Loba: Books I & II
Recollections of My Life as a Woman
Towers Down
The Ones I Used To Laugh With

TABLE OF CONTENTS

FOR DIANE

I've loved women all my life, this one especially—and for once I think I really know why. Williams, in a late poem, ends by saying, "The female principle of the world / is my appeal / in the extremity / to which I have come." We stretch out long on the earth, as men, thinking to take care of it, to give it specific form, to make manifest our experience in how we take hold. Yet there is no one there unless this other person of our reality take place too, with a generosity only possible in that act. Diane di Prima is fact of that "female principle" whereof Williams speaks—not simply, certainly not passively, but clearly, specifically, a woman as one might hope equally to be a man.

I am not speaking of roles, nor even of that political situation of persons she has so decisively herself entered at times. Nor of children and homes, though she has made both a deep and abiding pleasure in her own life and those related. It is some act of essential clarity I value—which in these initial occasions of her writing is already moving to declare itself: food, places, friends, nights, streets, dreams, the way. She is an adept and flexible provider of the real, which we eat daily or else we starve. She is kind but will not accept confusion. She is beautifully warm, but her nature balks at false responses. She is true.

Growing up in the fifties, you had to figure it out for yourself—which she did, and stayed open—as a woman, uninterested in any possibility of static investment or solution. Her search for human center is among the most moving I have witnessed—and she took her friends with her, though often it would have been simpler indeed to have gone alone. God bless her toughness and the deep gentleness of her hand!

—Robert Creeley

To my three pads
& the people
who shared them
with me. . .

What Morning Is

WHAT MORNING IS

First you wake up and it is daylight but wrong with some hood honking a horn in the street and again till you think you'll go out of your mind and you're not quite awake so you think rocks yes a rock at his head smash his face the bastard and then awake with eyes open and Freddie at the window standing all floppy in silly pajamas saying some people are rude and you think rude's not the word smash his face, and you say Good Morning Baby and then you sit up.

And then it's breakfast feel foolish old wool shirt moth holes too and all the pots dirty cook eggs over yesterday's eggs so what and the cat climbing up and down your pants leg four weeks old and a plague how I hate instant coffee. And Freddi-O says you're sad today Di don't know never know how I feel only yes when I write then I know and then there's how much weighs the laundry and Freddie late as usual cutting out.

So you bathe then hot water thank god and upstairs yes sun and the record Eroica and then find a book. Stein yes Stein on Picasso wish Freddie had books but she's cool. Still-life swings. Then standing in sun robe off stretch and again still-life swings '42 Paris yeah German shit and what else he's not screaming live thru it Beethoven too gone cat live thru anything lovely guitar nature morte yes calmer than life wow righter than cool we're so stupid. Just stand nothing on but the sun lots of it and you think yes OK I'll swing it.

April, 1957

13

What I Ate Where

the first i remember to tell of was the food on east fifth street. all kinds
of food on east fifth street but the kind i'm remembering now to tell of we
called menstrual pudding. it wasn't so bad really, was merely potatoes in
tomato sauce and that's all no spices even and no no meat. but to pre-
tend there was meat and that we were eating stew we put the tomato
sauce. the potatoes were just potatoes which are ok if you like potatoes.
some people i notice are crazy about potatoes. i'm not and never was, i
can't say menstrual pudding turned me against them, i just plain never
liked them to start with. not mashed not homefries not even
bakedidahowithbutter.

how come we called it that was this cat jack who was staying there at
the time, he had that kind of mind, i mean he called things things like
menstrual pudding. we ate it for three or four days as I remember, i was
going to say for breakfast lunch and supper, but that wouldn't be true
because we just gave up on those three, on breakfast lunch and supper i
mean, and ate when we couldn't help it, and after a while the potatoes
got mushier and mushier and finally the whole thing was almost only
mush. we added water too at the end if i remember.

it wouldn't have been so bad, menstrual pudding, if it weren't for the
color of the walls, taupe, which just didn't go with tomato sauce, no, and
especially not on grey days. how come the walls were taupe was we
wanted to paint them beige, that is i did, cause almost everybody else
said why not leave them grey in one room and pale yellow in the other

and not too dirty why paint them at all. but no i thought beige and black would be very chic and i wanted a very chic apartment especially for this very chic girl i knew who hardly ever came down there anyway but. so but to save money we bought white paint which is the cheapest, a dreadful grade of it that rubbed off like chalk when it dried but it was the cheapest, and we bought four gallons of it and with it a tube of paint tinter whatever you call it. i figured to get beige what you needed was a light offbrownish color, so i figured burnt sienna which i'm fond of anyway, a little of it in white would make beige. it didn't. it made pink. now pink walls (i tried it out) are not chic and they make you want to vomit, and besides i hate pink anything almost there are a couple of things pink which i don't hate but we won't mention them shall we, and they are anyway not walls. so we went out again to the paint store to figure out what to do with these four gallons of something what was it pink light-burnt-sienna which we had rashly mixed all of in a big pot-thing saying if we add a little more it will turn beige until it had become pink indeed and i mean it. and in the paint store we looked at the colors, all of us dancers, writers, folk singers, none of us painters in the least, looked at them and looked and tried to figure what mixed with this pinkstuff would make beige and finally settled on raw umber, which when we added turned the whole thing taupe. and we gave up and painted everything taupe by candlelight so we wouldn't have to see too much the color, and it was within these taupe walls which rubbed off like taupe chalk and were all runny of different shades of taupe that we ate our menstrual pudding on those four grey november days that year and how many of us there were i don't remember.

the next i remember is the hapsburg house oddly enough, but then again not so oddly either cause wouldn't you want to remember the hapsburg house after you remembered a thing like menstrual pudding? or don't you go in for extremes. I remember sitting there with this cat who was half cherokee with a spanish name, a beautiful cat with those cheekbones and lovely eyes, sitting there with him and ordering shrimp and wildrice in a cream sauce after first downstairs the martinis and the second one drunk in such a way that it was settled what we would do that night. and i was radiant very high with the early spring this was many years later, and pregnant but not knowing it yet, not even suspecting till the following week, and that night occupied simply with being beautiful and the talk which was if i remember of classical chinese how to study it and the cape in the winter.

and after the dinner we went to henri quatorze and the cherokee cat showed me off to some of his friends and i was courted and drinking pernod and water. the tablecloths i remember were red and white check very corny it was dark and downstairsy and there was that in my stomach. i mean that feeling that happens when you are about to go to bed with a cat for the first time, the sense of adventure the quick in the air, and i drank pernod being unconsciously pregnant and knowing how another winter chalked up. . . . we went home i remember to high ceilings and the firelight and he was the only cat i've ever known who could be sexy in his underwear even in his underwear there was something fey about it i still remember.

in the morning he left for the cape to go back to the cape and the next week the bad times began there began to be rats in the kitchen.

THANKSGIVING, 1955

MENU

clams on the half shell
roast duck
filet mignon
salad—mushrooms—asparagus
hot rolls
chablis—vin rosé
italian pastry

SHOPPING LIST

Clams
Meat
Parsley
Garlic
Dustpan
Hairpins
Mushrooms
Brandy?
Wine
Roasting Pan

GUEST LIST

Dick who whimsically married a bitch and whimsically and rather helplessly almost gets rid of her. Yes he eats everything though tentatively. Loose indescribable face.

Millicent the bitch who married Dick. She gave up dancing because acting was less work, wants an airconditioner in their forty-a-month east side apartment, hates children and wants none. Had a successful miscarriage and several tantrums while in the hospital recovering from it. She won't eat clams, or duck, or asparagus, or mushrooms. Nibbles at the pastry. Keeps saying nothankyou in a honeysouthern voice.

Dan who would rather have bean soup.

Bill who would rather eat at Downey's.

Michael who wishes there were oysters instead of clams and that we had made garlic bread. He eats everything in sight and is anyway full of exuberance which is something in this gathering. He eats lying on the whole bed. Squatters rights.

Peter who keeps saying um-good but could be eating liptons noodle soup for all he notices. He talks and draws pictures constantly between mouthfuls.

And us who invented this feast and eat it and love every bit and are bugged at Millicent which is how it should be when a woman comes to dinner in another woman's house.

There was even some wine left over.

i remember the winter the january i ate nothing but oreos. if you know what oreos are, they're those chocolate cookies two of them at a time stuck with sugar in the middle, and very addictive. i mean i really got hooked on them. there was this low armchair in my pad and i would sit in it and eat oreos and read and sometimes drink a little milk or water cause oreos in large numbers they tend to stick in your teeth.

when i wanted company i would go upstairs and visit these two girls who were my neighbors. they were a little crazy. they liked oreos too but not as much as i did, i mean not three or four packages a day, but anyway they would sit there and eat them with me to keep me company, and they washed theirs down with ale. ale and oreos i didn't dig too much, together like that. but boy, to hear the wind blow and all that awful january rain and a bunch of windows looking out on old crumbling filthy brick walls, and to sit in the middle of all this eating oreos and reading was—well anyway it was a way to get through january. to get through january in manhattan is hard, to get through january and february the same year almost impossible.

one of the best ways to get through i found was this of eating oreos. except that it makes you fat. really fat. even if you don't eat anything else and you think, shit, how can i get fat i haven't had breakfast or lunch or anything like that, but don't kid yourself. OREOS MAKE YOU FAT.

or maybe it's just me. the girls upstairs ate a lot of them, but i couldn't tell if they were getting fatter or skinnier because they never got out of bed. that was a weird pad. the bed was in the center of the center room and they were in the center of the bed. the edges of the bed were for ashtrays and beercans and beercan openers and pastels and oreos. and they had these red lights that they turned on all the time with that grey

outside it was too much, and dust over everything like you read about in biographies of proust and try to imagine but you hardly ever encounter it. real genuine dust-from-not-moving, from not capering about, not the kind of dust you 'raise' the kind that drifts slowly, settles in through a whole grey winter. we would sit and eat oreos and drink ale if there was any and sometimes one of them would draw in a black book with pastels and everytime it rained we would talk about the fallout.

and one day the girl who never drew said she would draw too, it was snowing, and she got out the other one's watercolors, and while the other one drank ale, and i did terrible abstract pastels, she carefully like a child drew an apple and a pear each two inches above a wobbly perspectivy table and carefully like a child she filled them all in with color, the pear yellow the apple orangy-red and the table brown and it was very beautiful. and she said There that's my still life what else is there to paint? and we said Landscapes. and so she drew a tree with a bird in it and a very tall flower stem and the flower on top of the stem was also the sun and it was like blake or rédon but much more childlike and lovely, and she said There, that's finished what else is there to paint. and we said People. and she drew and painted all in one color a grey blue a very all wrong lumpy disproportionate person who was not beautiful at all, and then she said There i have finished, i have mastered the art of painting. and we said to her No you haven't because your people aren't right yet. but she said That is how they are, and if they are not right i will be known as a painter of landscapes and still lifes.

and then i went out and brought back from the snow pastrami sandwiches and ale and yes more oreos and we waited for it to get dark.

Prevailing foods At Times

summer 1953—lamb chops, fresh tomatoes and pepperidge farm bread. this was the time of the chic girl and sometimes she came to visit and stayed to supper and she would eat nothing but lambchops or steak and sometimes a boiled vegetable with a little butter and pepperidge farm whole wheat bread with butter on it. which got to be very boring and i ate a whole lot more of it than she did because i never knew when she would come to dinner. she used my pad during the day while i was at work and i still remember how it was one day to come home and find her asleep in her slip, the white of the slip, the white of the sheets, and her skin, flushed with the afternoon sun on it.

fall 1953—kraft cheese spreads on pepperidge farm bread for lunch, this at work while doing latin, i was reading vergil i think, i worked in the credit department of a large sugar company.

february 1954—lunch tongues, liver spread, caviar, vienna sausages, anything that came in small enough jars. we lived off what we could steal from the a & p. sue had a navy coat with big stiff sleeves, i had a trench-coat with nice deep pockets, and jeri would slip a steak under his jacket cross his arms over his breast and swish out, rolling his eyes at the boys at the counter. we always bought bread.

spring 1955—a lot of scrambled eggs, at other people's pads. lived nowhere, had keys to a lot of places, and it seems whatever people are out of they always have a couple of eggs left. hate eggs.

summer 1955—potato pancakes in the back of a bookstore where i worked. the only store open by the time i remembered to shop being always a delicatessen with frozen potato pancakes, we thrived on potato pancakes, sour cream and coffee. night after night. me, and tim who was my lover, and ed who was blonde and silent and who i have never yet seen enough of.

winter 1955-56—english muffins 4 am at rudley's because no one could sleep, susan's lover, an actor, having a peculiar propensity for brooding, or talking on the phone, or getting into the wrong bed in this case my bed, in the middle of the night and creating general insomnia. after enough shifts and turns and muffled sighs one of us would finally sit bolt upright and say Let's go out for coffee, and that would finish the night. rudley's was on central park and the dawns were nice.

fall 1956—hopping john, which is brown rice and beans and wine and ham hocks; or else lentils and chicken gizzards with wine; or garbage soup which was everything cheap thrown in a pot. cooked in a four gallon kettle, enough for everybody, payment was always you brought up some wood for the fireplace. food was warm all night, you just took a bowl and sat down. nobody ever talked much, we looked at the fire.

is there a meal i remember, i mean a real meal? do i remember a meal? i remember my first chicken in white wine in a restaurant and my first lobster but they were not meals to remember. what i do remember are snacks again, more snacks.

i remember onion soup at rumpelmayer's very late it must have been. one of those nights it was that one doesn't like to remember it is still happening somewhere in space and time somewhere in the navel of one's horror and not a night to remember lightly but i remember it. or rather it still is here, to be talked about. its tail is curled, i swear, around its feet.

we had gone to dinner yes in the gold coin, whatever it's called, something like that in the chic east fifties with an Old Family Friend. it was

chinese food but so expensive you didn't know it was chinese, i mean there were no fried noodles or wonton soup, just all these strange things, and very good. then the Old Framily Fiend and i had an argument, which i will not mention by name, as it is sitting right here staring at me and it is bad manners to talk about a thing to its face. a very bad argument. purple feet, its tail is curled around, you can see for yourself. anyway it was the kind that ends with you are killing your parents, what right have you got to breathe out just because you breathed in, and there are already too many babies in new york.

so i got up and left the gold coin and it was raining and the men at the door said what was wrong with the service and should they call a cab and i said no, nothing and no, i had of course no money for a cab. so i walked to 60th street in the rain and waited for a crosstown bus, and home, where i vomited for the first time in my life from anger and cried for the millionth time in my life from anger i scarcely ever cry from anything else. vomited i remember right on the floor, sitting on the bed and crying, vomited. which splashed my new shoes or were they sneakers, i can't remember now but they were new at the time and it never quite came off; and splashed all over this orange face of a woman that pete had painted on the floor and we used to call it the face on the barroom floor though it wasn't like that at all, very stylized and still. there had been no more walls to paint on so he had painted on the floor.

and i got up and cleaned up the mess with some old clothes which i decided then and there were rags and threw water on it and put newspaper on the water and sat down again on the edge of the bed and looked at the newspapers and i think i probably started to cry again. and in came susan who had been dining with us and although she more or less agreed with me would never have left such a good meal just to gesturize, i mean walk out with me, only she came by after to see how i was and she saw. so she said, get dressed again, and wash your face, and let's go out and do something festive, and she was right. she was almost always right about festivities, it was just the times inbetween that she was wrong in and they were most of the time.

so i knew she was right this time and i got dressed again and we went to rumpelmayer's, which was one of the few places open at that hour. we could now that i think of it have gone to the russian tearoom, but maybe we didn't have enough money, i don't know, i know i didn't and you can always get a snack at rumpelmayer's. what i mean to say is rumpelmayer's is sue's idea of someplace festive but not mine at all, it's too much like an expensive luncheonette.

anyway we went there and maybe it was a good idea, yes i'm sure it was. because a highclass luncheonette is brightly lit and one cannot begin to weep all over again in a brightly lit luncheonette. maybe one on tenth avenue yes. but not one on central park south and not this one. so then it was what did i want and though it was may i was cold, was freezing cold so i ordered onion soup.

HOT PLATE COOKING—1955

Morton Street—mostly liptons soup at home. mostly ate out at Jim Atkins. mostly ate english muffins.

Charles Street—more like refrigerator cooking. hot plate not working. tried to keep milk in the community icebox. millions of red-haired whores and sloe-eyed junkies up all night waiting till you slept to steal your milk. once even tried to keep cottage cheese. left in two weeks.

Waverly Place—tim's room and he was bigger than it was. could stand in the middle and reach everything in the room. bean soup and very good

black coffee. and never to lift a finger, cause you might get something moved, out of place, oh lost. not to be borne, you understand of course. so you sat on the bed (cot) the only clear place in the room, and tim very long reached down from shelves different things, and you ate them content and waited on in the very hot room in the summer. the hot from the skylight partly cut off with a burlap across it. but still a very hot room. and always with visitors other ones too besides you. and you listened to tales of hitching, mostly tall, and of the army, mostly too grim to be lies, and of home wherever that was for the shifting people. one of them once stayed over, no room on the cot for three so he slept on the floor and was long too long and his feet stuck out into the hall.

West 16th Street—where susan went to live with her lover: beer mostly, and tears, hardly ever both at once.

West 20th Street—where i went to live without mine: tuna fish lots of it, and milk and butter. an icebox that worked. long room like a giant's coffin, painted blue, waterbugs and awful curtains no other problem. meticulous house. i mostly ate out, it was summer.

My First Meal In New York—
a very important episode.

i mean, my first meal in my own pad. i mean in something that was almost my own, we had after all paid the $10 that was that month's rent, in other words sublet it for the month, and we had come in from college and gone straight down there.

it was in one of those houses that are in courtyards in back of houses, and they hardly exist in new york anymore, hardly existed then, but this one did and there was a fireplace that worked in the front room. the man across the hall came out of his house and said you girls must be cold, it was october, and brought over all neatly tied a lot of wood. it had paint on it, the wood, was from constructions, and the paint when it burned smelled awful, but you see it was our own pad nobody else's and we were in it and a fire was in it and food was in it too.

when we first came in, it was so dirty we couldn't believe it, we had lived at home and then at college where once a week or twice i forget a maid comes in and cleans for you, and here it was our pad and it was filthy. jan started to sweep and scrub in the living room and i began in the kitchen. there were these three rooms, the bedroom in the middle. i cleaned for a long time all i remember about it is that there were bugs stuck in the dirt at the bottom of the drawer with the silverware and that upset me, it really did, i took out the silverware like i was playing pickup sticks, trying not to touch any bugs, and then i stuck the drawer under the faucet and turned on the tap and hoped it would wash it away, the dirt and the bugs too, but there was almost no water just a feeble trickle and all it did was get the dirt all soggy and so i had to get a rag and old dutch cleanser and scrub it out. almost it made me sick, but i was too excited to be sick and too happy. this was our pad, we had come here on the bus, with money borrowed, stolen, wired for, set aside, and here we were, i hadn't even signed out from school, and there would soon be a fire in the grate.

by the time the kitchen had emerged from the crust that was on it, jan had finished the living room and the bedroom, i remember she polished the mirror and wet her comb and combed for a long time her short dark wavy hair. and we pulled up a little table in front of the fire and set out our french bread and peanut butter and i brought in a pot of liptons soup, we thought we were being very economical and sensible.

and after we ate we made a great show of studying. we came to new

york we told each other to work. it was impossible to work at school. which was true enough, in that place if you locked your door when you opened it there were four people sitting outside wondering whether or not you had killed yourself. i mean to say you had no privacy. somebody went home from that place, thanksgiving that year and walked through the dining room where her folks were sitting and to the big french window and on out. four flights up. it was that kind of school.

but soon after, i mean a pretty short time after we ate, we gravitated one and then two to the mirror, i like to think jan first, and combed our hair, discussed calling someone we knew in barcelona, decided against it and set out.

the rats had already been several weeks in my kitchen when i began to have sunday brunch on madison avenue. i had it with two girls in their two and a half room apartment, they would rather i called it a flat, and while we were eating and eating very well, we ate blue cheese and caviar and sour cream and smoked ham and swedish bread and black coffee in lovely white thin cups, while we were eating we would sometimes do a little of the times crossword puzzle. brunch was usually at three o'clock or four which was when on sunday these girls would get up and sometimes if i had nothing else to do earlier i would get up and get a times and do part of the puzzle so we would be that much ahead. it was a big thing the puzzle. sometimes we finished it though i don't remember that we ever saved and checked it. the other big thing was the play one girl was writing which she had meant to be a novel, only there was this play con-test so she turned it into a play. it made a good story-type play that didn't win the play contest.

the talk aside from the puzzle and the play must have been little enough and rather unexciting, as i don't remember anything about it. i guess it was gossip about the family of the one girl, and oh yes, much much much about england, where she had been for a year and where she wanted to be. i think we also talked about byron and shelley. everything in the house was blue and white and like thin china, and dusty and muffled from the carpet on the floor which was grey and looked like it had been there for a long time, a very long time indeed. they had rented the place furnished.

i remember iced coffee made from powdered skim milk and coffee ice cubes and a sprinkle of cinnamon, and this was very good indeed. it was a very hot night, summer and august, in the same apartment where i later had my first meal in new york, and we were then still in high school or just graduating. it was a veritable gathering of maidens, enough to make your mouth water, enough even to make my mouth water in retrospect, how we were. we were all dressed in this new garment we had just invented, it was a half slip which you hung just above your breasts and tied with a sash just under your breasts or around your middle or low like a flapper on your hips if you wanted and if you had a longish one. they stopped high up and they were cool and comfortable in august and they looked good which counted dreadfully with us, though there was only us in the pad and we had all seen each other look good and not look good on a great many occasions. there was a mattress on the floor in the front room, the windows were open, sometimes a breeze, and endless supplies of this drink and it seems to me, i may be wrong, but it seems to me we were happy.

there were dozens and dozens of family dinners that happened to me after i left school, and they were all alike and all of them different. they have all of them run together in my head with no separations, and that is how i will tell them now, with no separations. mostly they were the dinners of holidays, of thanksgiving and christmas and easter and birthday parties. some of them were weddings and one that i remember was a funeral but i won't tell about that not this time.

on the days of family dinners you would come back to the house after not having been there for a very long time. you would come back in blue-jeans with holes in your sneakers and everyone would look sadly at you. one time i remember, an easter, not having the carfare to take the subway and walking in from manhattan over the bridge, from washington square with a friend who was hungry over the manhattan bridge and into south brooklyn. i didn't tell them we walked, i stole some change for carfare back to the city.

they would look sad but they would be glad to see you. you would eat some meat from the sauce while it was still cooking because of course you would have had no breakfast, and then you'd go up to your room and look at it, the things in it untouched since your last visit, except the furniture escaping one piece at a time and going to make up the furniture of other rooms. and you'd putter with papers and old letters and take out your files, just to see how they were all there, to know it. it gave you a good safe feeling that there was a place to send papers, a place to leave letters and books that you wouldn't be reading.

and after a while they'd say Diane come down to dinner and i would

come down to a house now full of aunts. there would mostly be little aunts, and one or two bigger, coats in two closets and on my mother's bed, and all my cousins some grown a good bit but no different, some a good deal different and that always happened fast. i had seventeen cousins in all, first cousins, i don't know how many aunts and uncles, and there were always the second the third and fourth cousins who just came over from italy and the great aunts. of them all i remember a few, aunt-olga because she cried a lot, her white hair curled and she had a nogood husband; aunt-julia who talked the most but was very lovely and young; aunt-jenny who always sang and was happy and happy. her husband was happy too, my uncle-larry, but he was more quiet about it and didn't sing much. i remember him well from the earlier days when he would be the one to give me books, cyrano i got from him, and penguin island.

we would start with the antipasto, the aunts would bustle. there would be dishes coming and going always and they would bustle. some would be washing things between the courses, others getting the salt or the vinegar for something, and all the time we'd be eating we ate all day. when the eating slowed down the kids would put on the phonograph and they would lindy and the older folks would wait and wait their turn and play a foxtrot. i learned to dance from them first, it took a long time to get rid of the way they danced. they danced like the twenties or thirties i don't know which, i guess it's thirties they danced like, the twenties movies i've seen show nothing like it. they danced without moving the upper part of their bodies, nothing moved from the waist up like on ballet dancers. the result on some of them was a really great tango, on most of them it was just ridiculous.

so i'd eat and eat and dance with the kids and with the older folks, i was sort of in the middle, and they would look sad, the older ones, and ask me if i was going back to school. and if i felt good i'd be honest and say no. they would ignore my bluejeans all of them except my mother and she would have taken me upstairs first thing to put on a dress, one of her dresses or one of the ones i'd left home, and i would say no, the hell with it and we'd go down again and join the others.

33

mostly it was good and not unpleasant. the evenings were good when we went back for seconds, the lukewarm meats when it got dark, the black coffee we drank with anisette, the fruit and nuts. my brother would play the piano and we would all sing. we sang the old songs left over from the war: bongo bongo bongo i don' wanna leave the congo, maria elena, and symphony of love. and then we sang older songs than that even, for the grownups. just a song at twilight, and desert song.

it would be really dark, and my mother would wrap up some meat and some italian food that i'd never cook for myself, and the bag would still be warm. i'd pick up the change i could find in the kitchen, and all the aunts would be in the process of leaving. then i would say some cool things to my brothers, take the food and go back to my part of the world.

TWO BIG DINNERS

and now i will tell you about the really big feasts. there were two of them as i said. i shall tell about them. one was for thanksgiving last year, one was christmas eve, and i don't know which one was better. the thanksgiving one we ate longer, we ate for nine hours, but christmas eve was darker and had more to drink.

the shopping for thanksgiving was very lovely and it was cold out. i took my shopping cart and arthur who lived next door i mean in the next apartment and we went to all these stores on the east side. there was at that time a vegetable market on east houston street, more expensive than the other east side vegetable markets, but very good, with everything very

fresh, and i bought yams and mushrooms and fennel and millions of salad things and avocados and chestnuts to cook with everything. already i had the turkey and sausage and all the italian goodies, the olives, alici, and the spices my forty-eight of them in test tubes in test tube racks marshalled at home. then arthur and i squeezed into the tiniest cheese store it had two other customers and it was overcrowded, i have noticed more cheese stores are like that are tiny like that, cheese stores and bread stores and no other kind of store. we bought fromage de brie and very good crumbly provolone and something new to me called kashkaval, cause the man said taste it and i did and it was marvelous. and then did i have enough apples and pears for the cheese so we went back to the vegetable store and bought more apples and pears. the man was taking in mushrooms as big as a fist, baskets of them from his car, but he wouldn't sell them he said they were for himself for his own thanksgiving. then we bought the wine, some of it, some was coming with people tomorrow and huge loaves of fresh italian bread because the man in the bread store said no he wouldn't open tomorrow and i wondered all the way home how to keep it fresh.

and i used my icebox and michael's icebox upstairs and arthur's next door because there was so much stuff. there was really a lot of stuff, oh much more than i've said. and boiled the chestnuts in wine and cooked sausage in spices and left it all standing together for overnight, it would all stuff the turkey. and the next morning early sara came over with many things among them fresh dill and we made three salads and i baked asparagus and made all the antipastos we used to have at home and finally it was three o'clock and people began to come.

the whole of the livingroom which was a bedroom became a diningroom with extra tables and there was running back and forth to all the iceboxes and soon we started eating and we ate as i said for nine hours altogether. grapefruit antipastos turkey mushrooms-and-sour-cream baked-asparagus-with-wine-and-cheese all three salads and yes of course candied yams and cranberry sauce though you weren't supposed to that year the newspapers said, they said the cranberry sauce was sprayed with

poison, but then we figured so was everything else and so were we, we ate four cans of cranberry sauce with the turkey.

and sam fell asleep on my bed. people kept falling asleep and waking up and eating and it got darker and darker and very late. and a painter came in a girl i used to know a girl i hadn't seen for two years with her child and ate too and i ate so much i remember for the first time in months not feeling cold. and al who had a show to light got there finally and said somebody at the theatre stole the walnuts and figs, he was bringing the walnuts and figs, and i said thank goodness we'd never eat them anyway. and we started him off from the first eating everything, eating all the things we had eaten until he caught up. and then we all got to the pastries and coffee and brandy and panforte and fruit and cheese.

and hugh came in with seth and said martin was sick so we made up a special package with pastries and all kind of goodies to send back to him, and hugh ate some and so did seth and there were three or four conversations going on at once. seth talked about jail, hugh talked about going to peru, al and rody and sam talked theatre shop. i kept stopping everybody to tell them to eat more things and tom warner kept trying to put in words about turkey, the country he meant, and nobody listened but he looked very happy. the baby took off her clothes and sang happy birthday and told us it was a party and we told her yes. when hugh was leaving we gave him a flower for martin.

yes, as i said i will tell you the other feast but first i will tell you about another meal which was a lovely one and nobody ate it.

it happened one night he was leaving, this lover, a lover i was in love with, and he said do you like raw clams? and i said yes i love them, i do i love raw clams i would eat them every day except i can't open them. people have tried and tried to show me how but i can't and so i only eat them at stands and in the cedar bar. ok he said i'll come by tomorrow in the afternoon and i'll bring clams lots of them i love them too and we'll have lunch. so i said fine and the next afternoon i took a bottle of wine, white wine i had been saving and put it in the icebox, and knowing him how he was always late i went into the study to think up something to do, a thing to do until he got there.

i took out a pair of dice and made some rules and began to write a play by chance, which is a good way to pass time and not very difficult, and at the time i called it six poets in search of a corkscrew, which was a title that had been hanging around. i used the radio and elizabethan plays and pieces of old poems and letters from people and i wrote this play and soon it got dark, i was still writing i wrote it out by hand, and then it was finished and still he hadn't come. so i cleaned the kitchen and took a shower and started, just about started to study greek, by then it was anyway nine o'clock or so and then somebody knocked on the door and it was him.

it was him he had forgotten all about the clams and i said do you want some wine and he said yes and we went inside, it was dark, we drank wine out of earthenware japanese tea cups and somehow the clams didn't matter one way or the other.

later on we did the play it was called paideuma.

and then there was christmas eve, the other dinner, there was snow on the ground when i shopped for that one, but that was quick shopping and almost all in one place. i shopped i remember in brooklyn in a fish store in brooklyn near my mother's house, the fish store she always goes to. fish is traditional italian food for christmas eve, and this is a good fish store, one of the best, and besides once in a while i like it to go back to brooklyn and see those houses, not more than four stories with lawns out front, even in winter that's nice, the houses are set back and there's light and air. and trees, lots of trees on every block the tree trunks black against the winter colors.

so i took the baby and went to brooklyn and bought six dozen clams and five pounds of shrimp, huge ones, and a lovely red snapper with a bugged look in his eyes and then went over to the tank where the eels were swimming. eels they keep alive till the last minute, eels are traditional on christmas eve, and the women were standing around the tank looking at them swimming and saying that one, no no that's the one i meant and the storekeepers would catch them in a net and then hold on to them hard and hit them and hit them against the floor till they were stunned and stopped wriggling and then they cut their heads off. and the older fat women looked on stolidly to make sure it was all done right, but the younger women got bugged and looked away when they started to bang their heads like that on the floor. and i said that one and picked out a medium sized eel and watched him kill it and wondered who in my house would eat it but me. and he said should he cut it for frying and i said no i wanted to bake it and he said it was a little bit small for baking

and started to tell me what to do so it wouldn't be too dry. and i left and then i remembered the squid and came back and bought two pounds of squid.

and that night tony came early, dinner was going to be at nine and found me cleaning shrimp and grumpy and said where's the food. and he had to go before there was any food because his kids were waiting for him uptown and he left bugged and wanting some dinner which didn't exist. the baby had eaten all three chocolate santaclauses, the one he brought her and the two he had bought for his kids. it was one of those nights people kept coming in at all hours and i cooked all through it, but all the food disappeared, not a scrap of eel left, all the too squeamish people succumbed when they had a taste. and al brought a buttermilk curry drink you had to drink hot and gene brought chinese firecrackers that let out bunches of streamers and we hung them on the tree. and rody brought lovely little wonderful tasting fruit cakes with rum sauce and there was eggnog and lots of people brought scotch. and peter came in from the army, came in and i saw register in his eyes how everything had changed in the two years, the people were different the food was certainly different and i was being a hostess.

and finally everyone left and i had still to wrap presents. louise stayed on she had come in late and she helped me. and for once in our lives we both said nothing uncool. the baby slept and i cleared the food away and she wrapped up the presents, the last of them was wrapped as it turned light and we slept.

Nightmares

Nightmare 1

Well, I had gotten to a warmer place for starving and lived on beaches,
and it seemed to me that everything would swing if I had some book or
other. So I wrote my mother (found paper) and told her General Delivery
and then I went back to beach and waited. Nights warm enough to sleep
and fish ok and paper occasionally a poem, and then it seemed like time
enough and I went to the post office.

A package I said a book my name is thus and they said identification
please. And I looked in all pockets but a lucky wave had gotten the cards
with my name.

Please I said, please please please. A book inside, Rimbaud, open and
look open for gods sake please.

Sorry they said why not go home they said and get your i.d.

Sure I said I'll ask that wave next time I see it but now give me package.

Sorry they said and put it on shelf
high
behind wire and screen. Rimbaud there and maybe food probably tucked
around. Salami and cans of things food you know.
Please I said please well good day.

Good day they said.

43

Nightmare 2

Having a cleaner house than usual I did the dishes. Gathering those long slime worms, dayold spaghetti, I dropped from the sink into the garbage them whereupon one slithered to the floor and lay there smirking.

Ugh I said but having a cleaner floor than usual I tried to pick it up, whereupon it nudged limply over and again smirked. After ten minutes of chase I with dirtier hands than usual gave up.

O well I said under the water faucet it will be hard as nails tonight the bastard and I'll pick it up stiff as a board.

Whereupon looking down again I saw a line of sleek roaches were marching the worm away and singing Onward Christian Roaches.

The din was unbearable and I remained horrored to the spot until a slightly larger roach, obviously leader, nudged me to see if I too could be carried off.

Nightmare 3

Spent fascinated hours watching the uncool of a young moth doing herself in at the flame of my nonessential bohemian candle.

Which was ok, till she sideways gave up and clicked to crisp end of nothing curled with small smoke.

Which was ok till from across ceiling room leaped flew another, raced, and screaming "Dido" followed her.

NIGHTMARE 4

Many days hungry laid out on tabledish raw chopped questionable meat probably edible, hope so, and went for matches.

Returned with frying pan somehow washed found on the table no meat, cat, no meat. Motherfucking bitch I said and flattened her with the frying pan squashed her bones practically dead and left her for tears. On bug-jumping bed I cried screamed and then cried to eventually recover and heel-toe to kitchen to see just to look and make sure.

On the table still flat now stiff lay cat all dead not hungry now, but trails of drying sometime blood to floor and back told how she'd gone to get the now beside her meal (she thought) for me, a mouse she killed and died.

NIGHTMARE 5

Knock knock

Who is it I said

The man he said to turn your meter off.

Sorry I said but I'm in bed and things and come back later please.

I'll wait he said.

Do that I said and gave him 57 hours 40 minutes to give up. Went out then to hall jon, eagerly.

Hello he said

Hello I said

Sorry he said to turn your meter off. I gotta make a buck he said I gotta family.

I know I said its what they always say and go ahead. When you go home I'll saw the damn lock off.

That wont work now he said they gotta alloy. Spent 30 million dollars making it. Cant saw it thru no matter what he said.

OK I said go to it and go home. I'm going to the jon.

I did, he did, he left, I found a chair. And tried saw hammer chisel tried slipped bruised nails tried tried saw tried. Soup to cook.

Twelve hours later went to druggist. Sam I said I have a charge account for bennies give me some hydrofluoric acid.

Mac he said I dont know. Bennies is one thing mac he said this acid jazz is something else.

Sam I said I gotta cook they locked the meter soup you know food you know.

OK mac he said but take it easy.

Drip

Hole also in table, floor, maybe downstairs dont know but hole in lock too soup open great. Wow.

But ha no matches jokes on me the gas on and no matches let it go. Plenty of gas guess I wont eat.

Nightmare 6

Get your cut throat off my knife.

Nightmare 7

One day I forgot my sleeve and my heart pinned to my arm was burning a hole there.

Discovered in pocket 50¢ no more; on 42nd looked for a pleasant movie.

Until the most beautiful god he was I think up to me hood walked and smiled knowing everything and then knowing.

Are you busy he said and I laughed because no busy would be busier than seeing him and he knew it.

And he laughed knowing all and acknowledging simply yes that is so there is garish and hurt but not us.

And walked all three him and me and our hands between and he had a room where the ceiling danced for me danced all night.

Till morning awakened and yawning with dirty teeth he said well babe now how much do you get?

NIGHTMARE 8

Then I was standing in line unemployment green institution green room
green people slow shuffle. Then to the man ahead said clerk-behind-desk,
folding papers bored & sticking on seals.

Here are your twenty reasons for living sir.

NIGHTMARE 9

Keep moving said the cop. The park closes at nine keep moving dammit.
God damn thing you think you own the park.

Not talking huh not going noplace? We'll see. Send you up for observation
a week of shock will do you good I bet.

And he blew his whistle.

Whereupon white car pulled up,
white attendants
who set about their job without emotion.
It wasnt the first time they'd seen a catatonic tree.

Nightmare 10

I saw it man, I read it in one of their god damned trade journals:

"Open season on people over 21 in dungarees or ancient sneakers,
men with lipstick,
women with crew cuts,
actors out of work,
poets of all descriptions. Bounty for heads ten dollars.
Junkies and jazz musicians five dollars extra."

You can say I'm mad but that dont mean I'm crazy. Ask any cabdriver.

Nightmare 11

I really must get a new vegetable brush. Everytime I forget and use it on
my face the vegetables I scrub next day turn brown and kinda strange. . .

Nightmare 12

I went to the clinic. I twisted my foot I said.

Whats your name they said and age and how much do you make and
whos your family dentist.

I told them and they told me to wait and I waited and they said come inside and I did.

Open your eye said the doctor you have something in it.

I hurt my foot I said.

Open your eye he said and I did and he took out the eyeball and washed it in a basin.

There he said and put it back that feels better doesnt it.

I guess so I said. Its all black I dont know. I hurt my foot I said.

Would you mind blinking he said one of your eyelashes is loose.

I think I said theres something the matter with my foot.

O he said. Perhaps you're right. I'll cut it off.

NIGHTMARE 13

It hurts to be murdered.

Memories of Childhood

1.

So I said to him Hey mister what're you doing with that H bomb how come you waving it around like that? You gonna drop it on that building? Hey mister how come you're taller than that there building, is it a Noptical Delusionment?

And he sez to me Go home boy, don't bother me. I'm telling you you make me nervous. Go home or I might get nervous and drop this thing.

So I went home.

2.

So my mother was in the kitchen and I ran in and I said to her Hey ma there's a big tall man outside boy is he really big and tall he's taller than our house and he's got this bomb in his hand. I think he's gonna drop this H bomb on our house. Hey ma I don't wan' him to drop it on our house.

So my mother went to the window and I went with her and I saw his legs standing there and I said There you see ma that's his legs and he's standing there you see him? And she said What are you talking about boy there's nothing out there but the tree.

53

3.

So I waited till my father came home and by then it was dark. And I said Pa I wanna show you something. And he said All right my boy what is it and put his briefcase down on the table.

And I said Pa did you notice anything funny when you came in the house tonight and he said Yes you didn't put your bike away and I said No pa that's not what I mean.

So I took him to the window and I said Pa do you see a man standing out there, a big tall man I can just see his two legs, huh pa?

And he said I do seem to see something out there, yes my boy I do.

And I said Good I'm glad you see it pa cause that man's standing there holding a bomb over our house, an H bomb I think pa and I want you to make him go away.

And he said Now wait a minute boy I think that's just the outline of the tree yes that's what it is it's getting dark out there and it had me fooled for a minute but there's no such thing as an H bomb you know son and there's no man out there.

4.

So we had supper and after supper I went to my grandfather's room to talk to him and I said Grandpa what happens if an H bomb falls? And he said A what sonny?

And I said An H bomb grandpa you know like an atomic bomb only

bigger I think. What happens if it falls? And he said It'll never happen sonny.

And I said Why not grandpa huh why not? Don't you believe in H bombs huh? Don't you think there's such a thing?

And he said I believe in god sonny and god will never let it happen now go play.

5.

So I went out to play and I got Dick and he said to me Hey you know there's a big tall man by my house and he's holding this bomb and my mother says he's not there.

I said You too the same thing with me what are we going to do.

We have to get it away from him Dick said before something happens.

So we went up to the roof and we took the clothes line and made lassos. And then Dick climbed the chimney and he yelled Hi-yo silver but he couldn't get it and ma started yelling for me to go to bed.

Then Dick took out his pocket flashlight and he shone it on the face of the Big Tall Man and the man was sleeping. He's sleeping Dick said to me Do you think he'll drop it while he's asleep and I said I don't know.

And then Dick's father came and walloped him good for not being in bed and I went home and they smacked me and I went to bed and I kept thinking he might drop it in his sleep especially if he had bad dreams.

Conversations

No Saviors for This Race

For Christ sake not the war again I thought.

Out loud I said: Where did you get the sling chairs?

Oh said Perry Brad's family gave them to us I think I'm not sure.

It's a nice loft I said.

Yes he said. Then he said the Budapest museum?

Yes I said the museum and most of the town too I suppose. Two da Vinci's were destroyed they think.

Brad came in. He said does anyone mind if I put on the phonograph?

For gods sake Brad said Perry not that Bach of yours.

Oh. Brad stopped dead for a minute. What do you want to hear?

One of the Russians I think. I have such a headache. How about Khachaturian?

Jesus I said do we have to?

How about Shostakovich said Brad the preludes and fugues.

OK said Perry. I have such a headache.

Brad put the record on the phonograph and sat down in a sling chair.

Jesus said Perry I wish I knew what happened to my pills.

Brad said to me do you really like the place.

Yes I said it's a good loft. It was.

I'm glad. He really glowed. It's great to live here.

Perry put his arm over his eyes. Brad he said what are you going to do if they call you?

Brad didn't look up. Avoid it he said.

Gene walked out of the kitchen and sat in the other sling chair.

How? said Perry.

Gene said you really think there's going to be another war?

Yes I said probably a week after the election.

My psychiatrist said Brad and if that doesn't work

It won't Perry said. He turned over and lay face down on the couch.

If that doesn't work Brad said I'll tell them I'm queer as a nine dollar bill.

That'll work said Perry if you do it.

I'll do it Brad said you think I'm crazy.

I said oh shit.

The army would finish me Brad said. He didn't sound too interested. It would be the end of me as a dancer.

Gene said what makes you so god damned sure there's going to be a war? We ignored him.

This Hungary thing hurts I said. It didn't seem like there was much else to talk about.

You'd think with all our ideals we'd step in or something said Perry.

What ideals? I said.

You don't really believe that said Gene. He sounded pretty scared.

Brad said they're doing something so tremendous over there. It's the first war that makes sense.

Like Spain I said.

What? said Gene.

Like Spain I said minus the Lincoln Brigade.

There was a lot of wine.

No Lincoln Brigade for us I said. We know the score. We were born knowing the score.

Maybe I should go said Brad. Maybe it'll be right to go.

Jesus I said what's the matter with you?

Where the hell are my pills? said Perry. He was beginning to look sick.

Gene said that's what I think. I don't think I have the right to stay home if other people go to war. I'm no better than anybody else.

It would be right to go to Budapest Brad said.

You think they'd send you to Hungary? I said. They'll never go to Hungary. You'll wind up fighting for an oil field.

I got up to turn the record over.

You guys make me sick I said. I was really mad. You know it's stupid and you always swear you're gonna stay out but you never do.

All wars are stupid said Perry. Would you see if they're in my coat?

That's how I feel said Gene. You can't stay home just because it's stupid. You can't stay home and watch the other guys go.

I'll never fight for something I don't believe in Brad said.

Whatever that means I said. Brad didn't say anything.

You can't think like that Gene said. You can't afford to be an individual in wartime.

Oh wow I said. I didn't want to bother talking to him.

Aren't they in my pocket Perry wanted to know. Brad got up and looked.

No he said they're not. You want a glass of water.

Perry turned on his side and looked at the wall. He pulled the sheet over his head.

I'm not better than other people Gene said. You see what I mean.

I'd fight for survival said Brad.

What's that I said. I felt like sulking.

I don't know what it is said Brad.

I'll fight for survival I said. I'm going to buy a hatchet and a heavy chain.

What for said Gene. He thought I was cracked.

Crowds I said. There'll be panics in the streets.

Wouldn't it be easier he said to get out now?

Sure I said it would be easier.

No said Brad you can't just do that.

I said if you can't stop the whole damned thing you might as well ignore it. Everything was very clear.

Gene didn't say anything else.

Brad said you gotta keep doing whatever you do.

Only do it better I said and enjoy it more.

It was clear as day. The two of us smiled at each other.

The record was over. Gene got up and took it off.

I read in a science fiction book the other day where some guys came from another planet and fixed everything up Perry said. He was still under the sheet.

Not this time I said.

THE CONFERENCE

Well I said that's the layout. Now what?

Now we raise money said Mark.

Do you have any coal said Brad. He poked the fire. How much do we need he said.

Seven dollars and seventy-five cents I told him.

That's not so bad Brad said.

No I said. It's not bad but where do we get it?

Mark said I can spare a dollar this week. He took out his wallet.

No you can't I told him. You have to get a room.

That's right he said. I forgot.

I put some wood on the fire.

Let's not talk about it now I said. Do you want some coffee.

Brad was doing triple pirouettes. He was pushing too hard and they were lousy. I went into the kitchen.

Don't move that chair Mark said to him. I'm drawing it.

I'm sorry said Brad. He sat on the bed and pointed his feet.

QXR began to play america the beautiful. Mark got up and turned it off. Jesus he said it's one o'clock.

Did I tell you what happened Brad said.

No I said. What happened now?

Gene cut Brad said. He left with the rent money.

Great I said. What are you going to do?

I've been looking for him Brad said. He took my good suit too. He put milk in the coffee. I'd really like to find him he said. I'd like to beat the shit out of him.

Don't get hurt I said. Brad said don't be silly.

The cover is good too said Mark. It's one of the best things I've done. Then he said didn't you put sugar in this god damned stuff?

We can talk about it tomorrow I said. I gave him the sugar.

He poured it all into his cup and stirred it for a long time.

It's a god damned good cover he said.

Brad said I'm cold.

There's more wood in the next room I told him. In a cardboard box. He went to get it.

We've been trying to do it for such a long time Brad said.

He put the wood on the fire.

A year I said.

More said Mark. He was drawing the broom.

The only thing to do I said is collect a quarter from everybody.

Like who said Mark.

Like everybody who's working I said.

You know how many that is said Mark. He stopped for a minute. That's 31 quarters. Do we know 31 people who work.

No I said I guess we don't know 31 people who work.

Sit still said Mark. I want to draw you.

Brad got up and put a record on the phonograph. The needle was lousy.

I sat still. It was very cold. When Mark got through I got up to get some more wood.

Brad I said where's the rest of the wood.

I finished it Brad said. He was doing tendues to the Masquerade Suite.

I brought the cardboard box in and put it on the fire.

Brad sat on the floor near the fire. Sometimes I feel trapped he said.

It's not really that bad said Mark. I know what you mean but it's not that bad.

Like a poem I was reading Brad said. He didn't hear Mark.

I think you have it he said to me. He went to the bookcase.

O helpless few in my country Brad said. He was reading out loud.

No I said. I got up and took the book. We're not helpless I told him.

THE ART CLASS

You have such a lyrical face said Irma. She poked her canvas.

Doesn't she said Margot. She has the face of a poet.

Well you know she is a poet Martin said. He beamed at the class.

The class beamed back at him. He was a very well known artist.

Isn't it marvelous said Betty to have a model who's a poet.

67

Yes said Irma and she has such a poetical face too.

You know Martin said Margot they're having another exhibit at the North Shore Gallery. And it's just full of those terrible abstractionists.

You mean like Pollock said Betty.

Well yes Margot said.

I like Pollock said Betty.

Nobody answered her.

They're such faddists Irma said. She belonged to the Old School.

It doesn't mean anything to me said Martin. He hated abstract art.

Landowska was playing the Goldberg Variations. Margot went over to the radio and flipped the dial. I can't paint to serious music she said. I like to relax. She started to sing Just Walking in the Rain.

They might be faddists said Betty but they're selling.

It'll pass said Martin. It is fashionable that's all.

Certainly it will said Irma. She took off her shoes.

Betty stepped back and knocked a brush off the table.

Be careful said Margot. She looked down at her dress. It was very chic and she never wore a smock. Then she said Martin would you please fix this hand.

Martin came over and painted for a few minutes.

There said Margot that's much better.

That's all Martin said to me. I started to get dressed.

She is very poetic said Irma. Margot was stretching a new canvas. High grade belgian linen.

Even the way she dresses Irma said look at that scarf. She smiled at me.

Irma Betty said come and look at this. I think I got the distortion pretty good. Don't you think so?

Irma smiled again. She felt very superior. She said just because it's ugly darling doesn't mean it's art.

WHILE THEY LAST

Let me sit on the inside I said.

Why said Mark. He stood back and let me slide in.

I don't know I said. It's a habit. We piled the secondhand books we had just bought on the extra chair.

I have fifty-five cents I said. Does anybody need some bread?

No Jack said. I just want coffee.

I'll go said Mark. We don't all have to go.

My feet stopped being numb and I could feel how wet my socks were. One of them was wetter than the other because there was a hole in one shoe.

Jack took off his coat and hung it on the chair. You could see where the lining was wet. There was something going on he said. Man you could feel it.

Like what I said. I was never sure what he was talking about.

Before he said. He looked grim.

What was going on? I asked him. Sometimes he told you if you kept trying.

In the gallery he said. Like what was the matter with us?

I felt sick to my stomach I said. Is that what you mean.

No he said.

Then he said I felt sick too.

It's cause we felt so good I said when we went in.

Were we feeling good Jack said. He looked around for a cigarette and couldn't find any. Yeah he said I guess we were.

We were high I said. And that shit was such a comedown.

Mark came back with the coffee. He put it on the table and stood there holding the tray.

Like we're drowning in shit I said.

I guess that's it Jack said. I'm not sure now. Then he said I should be sure.

He was drawing illustrations for Les Fleurs du Mal. The table was covered with them.

Why do you always have to know I said you always have to know everything.

Jack didn't say anything.

Let's do something tonight Mark said to me. I didn't pay any attention to him.

Like nobody knows anything I said to Jack.

Are you gonna be home tonight Mark said.

I've got to see Eric I said. He's flipping.

What's the matter with him now Mark said. He didn't like Eric.

Nothing I said. Only all his friends are kicking off.

Like who Mark said. He didn't give a damn who.

Chris Thompson I said.

Oh said Mark. He was very surprised. I used to know Chris Thompson. I didn't know he died.

I know you didn't know I said. I only told you three times. I figured you'd hear me sooner or later.

Mark grinned at me. He never heard anything.

Jack put his feet on top of the books and slumped over his drawings.

But they're not perfect he said. They're never perfect. There's always something missing.

Jesus I said. What do you want.

I want them to be perfect he said. With nothing missing.

Yeah I said. We didn't talk about it.

He died of TB I said to Mark. He wasn't listening. Half of that bunch probably has TB I said.

Probably he said. He hadn't heard a word.

Jack pushed his chair back and one of the books fell down.

It was Van Gogh's letters to his brother. I picked it up and started reading.

Oh and he's depressed for another reason I said to Mark. Omar hung himself. I knew he didn't hear me and I wanted to get it said. He was fifteen I said.

Wow said Mark do you know how old that song is? He started to sing Don't Sit Under the Apple Tree.

Jack looked to see what I was reading. I don't know man he said. That cat knows something but like he can't tell you anything.

He sat there fixing one of his drawings. He was bugged at Van Gogh.

Does anybody else want more coffee? I said. I was getting warmer and the place felt chilly.

No said Jack. He didn't have any more money.

I picked up the book and got on line. I wanted to read while I was waiting.

A bum got on line in back of me. He stank. Hey girlie he said what are you reading. He took the book out of my hand.

O for Christ sake I started to say, but I didn't.

Then the bum gave me back the book. He grinned. He said hey girlie he write those before or after he cut off his ear?

THE QUARREL

You know I said to Mark that I'm furious at you.

No he said are you bugged. He was drawing Brad who was asleep on the bed.

Yes I said I'm pretty god damned bugged. I sat down by the fire and stuck my feet out to warm them up.

Jesus I thought you think it's so easy. There you sit innocence personified. I didn't say anything else to him.

You know I thought I've got work to do too sometimes.

In fact I probably have just as fucking much work to do as you do.

A piece of wood fell out of the fire and I poked it back in with my toe.

I am sick I said to the woodpile of doing dishes. I am just as lazy as you. Maybe lazier. The toe of my shoe was scorched from the fire and I rubbed it where the suede was gone.

Just because I happen to be a chick I thought.

Mark finished one drawing and looked at it. Then he put it down and started another one.

It's damned arrogant of you I thought to assume that only you have things to do. Especially tonight.

And what a god damned concession it was for me to bother to tell you that I was bugged at all I said to the back of his neck. I didn't say it out loud.

I got up and went into the kitchen to do the dishes. And shit I thought I probably won't bother again. But I'll get bugged and not bother to tell you and after a while everything will be awful and I'll never say anything because it's so fucking uncool to talk about it. And that I thought will be that and what a shame.

Hey hon Mark yelled at me from the living room. It says here Picasso produces fourteen hours a day.

THE FRENCHMAN

Leon said come here will you. He was using his accent.

What is it I said. I threw out an old piece of brillo.

Come here he said and talk to me.

OK I said. I scrubbed the oatmeal out of the double boiler. You start.

I have missed you he said. Then he said come here.

He sat down on the stove. There was a roach on the pot and I watched it climb up his elbow.

Hey man I said have they sent up that rocket. Wayne had broken a cup and left the pieces in the sink. I threw them into a bag of garbage.

It is five days he said since I saw you.

I said oh.

I went to the stove to start the soup. Leon put his arm around me. He was still sitting on the stove.

Peep-bo I said. I ducked under his arm.

What said Leon.

Honk honk I said. Like you're in the way man.

He got off the stove and knocked the garbage over. Then he said this pad is so european.

He picked up the garbage and then he came over and put both arms around me. I stood still and waited for him to let go. After a while he said what are you thinking about.

Gizzards I said. They're twentynine cents a pound.

He let go of me. What he said.

Gizzards I said. From chickens. I waved one at him. They used to be nineteen cents I told him. I put a cover on the soup and lit the gas.

Oh he said. He sat down on the stepstool. Then he said let's go to bed.

Oh shit I said. I threw the onion peels at the garbage and some of them landed near the rat hole.

Like man I said you're being uncool.

Yes he said I am uncool. He was proud of it.

THE POET

You gotta love he said. The world is full of children of sorrow and I am always sad.

He was watching this cat beat up his chick in the street.

Sure man I said. The children of sorrow.

The chick had nothing on but her bra and pants and she was kneeling on the sidewalk.

All over the world he said the children are weeping. I weep with all the

children in the world.

Great I said.

The cat kept saying get up get up you fucking whore but the chick just knelt on the sidewalk.

I weep he said and my tears are part of all the children's tears.

A lot of people stood around watching. They didn't say anything.

You don't understand he said. Then he said you're very hard.

The fuzz was driving down the avenue and they pulled up to dig the scene.

Don't you love he said.

Sure I said. I love all kinds of things.

And the children he said. Don't you love all the lost children.

The cops put the cat into the car. He was still yelling you fucking whore.

Shit man I said. I told you.

The chick was still kneeling there. She picked up her clothes.

No he said that's not what I mean.

She stood there holding her dress. Then she put on her coat and walked away.

That's not enough he said. You gotta love. I love all the lost children.

I know I said. And you weep.

77

Some Fool Thing

Anyway I said you can always be a painter.

Brad picked up his coffee and clinked the ice around. That was a nice movie he said.

Sure I said. That's a nice limp. Byronesque. I wasn't getting anywhere.

Brad blew the paper off his straw and it hit the back of my chair. He said the French make such wonderful movies.

For christ sake I said. If you're tired of dancing give it up can't you without ripping up your tendons.

Brad said I'm not tired of dancing.

Great I said then go to the doctor.

All dancers hurt their ankles said Brad. He put on his clever professional look.

Yes I said. Most of them go to the doctor.

Brad put his ankle on the bench and looked at it. It just has to heal he said. Doctor can't do anything.

They have this new thing now I said. Called x-rays. Find out all kinds of things.

There's nothing to find out Brad said.

He put down his coffee and started cruising the next table. There was this little blonde trick who was laying it on.

I got up and went to the toilet. When I got back Brad was talking to the little blonde. I figured he was all set so I finished my coffee.

Wait a minute Brad said. He picked up the check. When we got outside I said you didn't have to leave.

Christ he said I have better taste than that. He was laughing.

We took the bus to Brad's place. He lives on the fifth floor and we took it slow on the stairs.

Brad put up the cots. Then he took off the bandage and looked at his ankle for a long time. Neither of us said anything.

I turned off the light. Brad said are you still mad at me.

No I said. There was a light on across the street and I could see him.

I'm not mad I said. I love you and I'm scared.

I'll be all right Brad said. Then he said I'm scared too.

I went over to the cot and kissed him. His skin was cold and loose. I pushed the hair off his face and grinned.

Don't go and do some fool thing I said. I was very tired.

The Start of Winter

Brad said OK let's do it.

Do what I said. He was talking about renting a theatre.

You know what he said.

Yes I said I think so.

Brad didn't say anything for a while. Then he said like I'm not getting into the ballet company.

You don't know yet I told him. You might get in.

No he said. It's in the air.

The air might change I said. By April.

No he said. I'm not going to think about it.

We didn't say anything for a while. Then I said you really think we should do it.

Yes he said.

Without goofing this time I asked him. I was pushing.

Yes he said without goofing. Then he said how many months till April.

I counted. Five I told him. We've been goofing on each other for three years I said.

Five he said. Then he said no I won't make it.

I said Mark won't be here. They'll probably station him in Australia.

Yes he said that's another reason.

Like they're invading the family I said. The fucking bastards. Then I said we're running out of time.

Brad didn't say anything.

It'll really be work I told him. I'll have to rewrite the whole play.

Brad said shit I wanted to go to Europe with them.

It would be nice I said. While Europe is still there. Then I said maybe it should be three acts. I started to tell him how it was.

Brad was staring at the wall. He didn't say anything.

I said you haven't heard a word have you.

What he said. He tried to look interested.

I laughed at him. Then I said what were you thinking about.

Nothing he said. About what dancers I'll use. Then he said how did you know I wasn't listening.

It's nice I told him. Everybody listens too fucking much.

I went on thinking about the play. Then I thought about Mark and how we had goofed the last three winters. I thought a long time about how we goofed.

Maybe we better do it before April I told Brad. Just in case you make the company.

The Visitor

Well he said so you're Lee. He stood in the doorway.

Yes I said. I didn't know him. I'm Lee.

I've been wanting to meet you he said. Jackie told me about you.

Oh I said. Come in.

He came in and sat down on the bed.

The kid who's in Rockland State I said. How is she.

She's fine he said. He smiled. I mean she really is fine. She likes it there he said.

Great I said. He gave me the creeps. Look I said what did you want to see me about?

That's where I met Jackie he said. In Rockland. In occupational therapy. We made things.

Oh I said.

You write poetry he said. He looked at me.

Yeah I said.

Jackie showed me some poetry you wrote he said. You sent it to her in a letter.

Did I? I said. I didn't remember.

He said yeah you sent it to her. Then he said why do you write poetry.

I didn't say anything. I had stopped thinking about that one a long time ago.

I used to write poetry he said.

Did you? I said.

Yeah he said. I used to write all the time.

Why did you stop? I said. I didn't know what else to say.

I burned it all he said. Just before I went to Rockland.

Oh I said.

Jackie gave me your address he said. It was on the envelope. Then he said I can't see why anybody does anything.

I said shit man you gotta do something. I said it very loud.

He sat there a while. It was getting dark. I turned on all the lights in the house.

Then he said I started doing it again.

You did? I said.

Yes he said. Sometimes I just do it. I can't help it. Then he said I haven't burned any of it yet.

That's good I said. I figured he still meant poetry. I'd like to see some of it.

Maybe I'll stop when I get a job he said. Do you think so?

83

I didn't say anything.

I hope so he said it's so stupid to write.

I'd really like to see some of your stuff I said to him.

It's nice of you he said. I liked your stuff. Jackie showed me.

He got up and put his coat on. I wrote a lot yesterday he said. Fourteen hours.

He went to the door. I guess I'll stop soon he said or else I'll burn it again. He sort of laughed. I opened the door for him.

Maybe I'll burn it again he said.

Bring it up sometime I said. I'd like to read it.

He was in the hallway but he stopped and looked at me.

I really would like to read it I said to him.

Yeah he said.

THE LOVERS

It would be nice she said to have a whole night sometime. She tied her shoe. We used to be careless with nights she said when we had them.

Wow he said. Weren't we.

Shit she said why not? There were always more.

Yeah he said.

You never slept much she said. She was remembering how it was.

Almost every night there'd be somebody different he said. That's how I knew it was a different night. He grinned at her.

It's still like that here she told him. I'm a spendthrift with nights. She combed her hair.

Shit he said.

What are you looking for she said.

My tie he said.

Oh she said. Sure. I forgot. You wear a tie now don't you.

He got up. I'm going to be first he said. I'm going to be the most famous philosopher in America.

The tie was on the floor. She picked it up and gave it to him.

Yeah she said. But I got bigger stakes than that.

Poetry? he said.

Yeah she said. Poetry.

Yeah he said. Well that's nice too. He didn't look at her.

The hell with it she said. Do you want some more cognac.

Yeah he said. Then he said my poor wife I shouldn't be late.

What's the matter with your wife she said. She didn't give a damn.

Guess he said. She's pregnant.

Oh she said good. Then she said is it good?

No he said. I can't afford a kid. Not till next year.

Bullshit she said. You wanted one four years ago. I suppose you could afford it then.

He didn't say anything.

I think I'll have a kid of yours myself she told him. I'll bring it up on lentils.

Wow he said. Let me know if you do. He didn't laugh.

The coffee got cold she said. I'll heat it.

No he said. I don't have time. He started to drink it.

Did you get to see Bill she said. She knew he had. He was in town this week too she said. She started putting the bed together.

No he said I didn't see anyone.

Jesus she thought why lie to me I'm not your wife. She didn't say anything.

I have to go he said. I'm very late.

Then he said you'll come to Michigan?

Sure she said. When I've got bread. She took the coffee cups into the kitchen.

I've got money he said. The hell with that.

He started to look for his coat and then he stopped. You know he said I don't want to go.

There's always a chance he said that sometime I won't go. That's the hell of it.

She came out of the kitchen and looked at him. She didn't say anything. Then she grinned.

You'll go she told him.

AND FACE THE DAY

I was watching a mobile. It was a Calder—circles and discs inside each other and if it hit it right it would be a straight line. I waited for it to hit it.

The alarm went off and then Brad came in. He was being very quiet.

He opened the drapes and looked at the day. It was grey as dawn. He started to go back inside and then he saw I was awake.

Good morning I said.

87

Good morning he said. He kissed me on the cheek.

I sat up and rumpled his hair. It's dark I said. Where the hell is the sun.

I haven't got it Brad said. Did you sleep OK? He hated to have his hair rumpled.

What do you think? I said. We had worked till three. I didn't sleep I said I blacked out.

I didn't Brad said. I was thinking. He sat down on the bed.

Oh I said. You would have done better to sleep.

No he said I had to think. I had to think about the solo.

I didn't think I said. I dreamed. I got up and went into the kitchen.

I dreamed about that other ballet of yours I told him. I dreamed we had a bullfight in my pad. I started to get breakfast.

Brad came into the kitchen. Put on some shoes he said the floor's dirty. He had a thing about the floors.

Big deal I said. So am I. I held up my foot and wiggled the toes at him. We had this bullfight in my pad so you could get the feel of it I told him. I was bugged at the idea.

Brad was still looking at my feet. How he said did you get such dirty feet.

It's the holes I said. In the shoes. There's always being holes I said. I came on like Marlon Brando.

Brad was laughing. He laughed a lot. I took the bacon off the skillet.

Shit I said there's not a clean dish in this pad. I stood there holding the bacon on a fork. The cat started climbing up my pajamas to get it. I threw her across the room with my left hand.

Wash two plates will you I said to Brad. I put the bacon in a bowl.

OK he said. He looked for the cleanest plates to wash. I'm tired he said. I should have slept.

Sleep after work I said. I beat the eggs. You don't have a rehearsal today. I had to yell cause the sink was out in the hall.

That's what you think he said. I do. He came back with the plates. I hate Joe Walker he said.

Yeah I said. He's an insect. I put the eggs on the wet plates.

Brad laughed.

He's a eunuch he said. I can't stand him.

It's just a week I told him. After the show you won't have to talk to him.

The dance is OK Brad said. I like it again.

You should like it I told him. You did the choreography. I moved my plate to cover a sticky spot on the table.

Yeah Brad said I guess so. But most of the time I hate it. He stood there looking at the floor.

Sit down I said. The eggs are cold already.

He sat down. You should wear shoes he said.

The cat climbed up on my lap and looked at the table. You'd better feed her I said to Brad you didn't feed her yesterday.

You feed her Brad said. I'm scared to death of her.

How the hell can you be scared of her I said. She's still a kitten.

She scratches Brad said. His mouth was full of egg.

I bet she scratches I said. I gave her some food.

She might not scratch I said if you didn't throw her across the room.

Brad didn't say anything. He was poking the bacon. How did the bacon get like this he said. It's curly.

I put it in the bowl I told him. There were no plates.

He kept poking it and a piece rolled to the floor. The cat went over and ate it.

Brad looked miserable. I wish it was all over he said. Isn't it ever going to be over?

It'll be over I said. Real soon. I gave him some frozen orange juice.

Yes he said and where are the sets.

Mark's been sick I told him. I didn't want to talk about it.

I know Brad said. He's been sick. You told me. He was bugged.

Yes I said he's still very weak.

Even if he is Brad said. I still didn't expect him to pull something like this.

I said he couldn't do anything else could he? I was bugged at Mark too and I didn't like to defend him.

I guess not Brad said. But I'm still disappointed in him.

Yeah I said.

Shit he said he could have done the sets. He could have drawn them in bed if he was that sick. I didn't say anything.

Only two of us to count on I thought. Not Jan. Brad and Mark. And it looks like not Mark. I didn't say anything else. I felt sick. I picked up a glass of milk and started to drink it.

Brad was watching me. He started to say something and then he stopped.

I grinned at him. Anyway I said it will come off OK it always does.

I guess so he said.

He turned on the radio. It started to play a waltz.

For god's sake I said. What's that thing on for.

Don't you like it Brad said. He turned it off again.

I don't care I said. Only it lets in all the shit from outside.

Brad poured another cup of coffee. This pad still needs so much work he said.

It's a good pad I told him.

It will be he said. When it's finished. He drank some coffee. I hope he said I live till then. He really looked tired.

You could come back uptown for a while I told him. You could stay at the pad with Mark and me. After the show it would be some kind of vacation.

Brad didn't say anything. He was throwing bread crumbs at the cat.

We might even pamper you I told him. How about it.

No Brad said I'd never get any sleep.

Also I told him you're not sure what would happen with the three of us in one bed.

You're terribly aware of that Brad said aren't you? He was talking slowly.

Yes I said shouldn't I talk about it?

If you want to Brad said why not. He meant no. Then he said Mark and I could be lovers.

I know I said but why in hell should it bug you?

It does Brad said. He went inside to shave.

I put on some underwear and then I followed him into the bathroom to wash my feet.

The dirt comes in thru the cracks he said. In the floor.

Are you busy this afternoon I said. There's a movie at the museum.

Can't make it Brad said. I have to go to the bugman. Shit.

I thought you were going to finish that off I said.

Parents he said I can't. They're all worked up about the queer bit again.

Shit man I said nearly everybody's bisexual.

Brad didn't answer he was putting on his shirt.

I looked at the dishes. They were covered with egg yolk. Jesus I thought I'm stupid sometimes.

I went inside and sat in the sling chair. I didn't say anything else.

The phone rang and Brad answered it. A voice came thru the receiver all over the room. I could tell by the rhythm that somebody was very excited.

Brad came back and finished making the bed. He said I hate that type.

What type I said.

Piss-elegant queen he said. He hung my pajamas on a nail.

Is Jan coming to rehearsal today I asked him.

I think so he said. I don't know.

I'm worried about her I told him. She's sort of flippish.

She's just restless he said. It's that Madison Avenue pad. You miss her a lot he said don't you?

Sure I miss her I told him. We lived together for three years.

Why do you think she went off like that he said.

I don't know I said. Maybe she just got tired of being poor.

She shouldn't be poor Brad said. He was stuffing things into his ballet bag.

No I said. She should have beautiful textures and shapes—the whole bit. Clothes, wineglasses—you know. I smiled.

Brad looked at me. He wasn't smiling. Yeah he said.

Anyway I said. See what you can do when you see her. Cheer her up or something.

He picked up his bag and started to go out the door. Then he came back and kissed me on the mouth. His lips were shut.

I love you he said but I'm queer.

I touched the hollow in his face, just under the cheekbone. I know I said don't worry. It's not important.

New York Is a Summer Festival

The rats were all right I said it was the rooster.

What rooster said Leon. He was tying up books.

The one down the hall I said. That crows.

Leon said hand me the scissors will you. He looked at me like I was having a nervous breakdown.

Where did you put them I asked him. There really is a rooster I said. I didn't make it up.

Yes said Leon. I suppose so. He took the scissors out of a box of silverware I was packing and finished tying the pile of books. What are you going to do with this wood? he asked me. He started to throw it all on the fire.

Wait a minute I said. I have to look at it. Some of it is for sculpting.

Oh said Leon. He went back to tying books.

There was a knock on the door and Mark came in. Jack and Ella were with him. Hi he said we came to help.

Hi I said Leon has the twine. I went to the kitchen and started cooking a lot of spaghetti. Hey Mark I said. I had to yell. Do you believe that there's a rooster across the hall?

Sure said Mark. Why not. Everything exists. He was drawing a two-headed monster. Then he said I'm tired of realism.

Yes I said but you're tired of abstractionism too.

Leon said abstract art is the only real art. He looked solemn.

Yes said Mark. I'm tired of abstractionism. I want to draw myths.

Oh man said Jack. He was bugged. He put on his coat and left.

Shit I said he didn't have to slam the door. The spaghetti was cooked and we all stopped working and ate it. Nobody said anything, we looked at the fire.

What do you want to do with these clothes said Ella. All the clothes in the pad were piled up on the mattress.

Put the dirty ones in the hamper with the dishes I said. I was reading old letters and putting them into the fire.

Ella said I can't tell which ones are dirty. She started stuffing them all into the hamper.

It says here I said to Mark that Jan's leaving college.

Wow he said let me see that how long ago was that?

We both stood there reading letters. Leon finished tying up books and he started putting the records into their covers.

He said where is the cover for Walking by Miles Davis? He spoke English very precisely, being French.

Use the Paderewski violin concerto I told him.

I said the rooster belongs to the new Puerto Rican family. They're really pretty strange, the little girl was in the hall jon last week burning her dress because she tore it. She thought this way nobody would find out. I burned the rest of the letters without looking at them.

Leon just said Oh. He tied up the last of the records.

By this time nearly everything was in boxes. I walked thru the pad looking at what was left.

I'm leaving the mirrors I said and the dirty sheets.

Ella said and the dishes we just ate out of. She got her coat and went downstairs to wait.

Mark said here this is for you. He gave me a very big two-headed monster. He and Leon started moving out the boxes.

Thanks I said. I was reading the writing on the walls of the pad. It said The unicorns shall inherit the earth. It said Sacrifice everything for the clean line.

I walked to the hall and put the drawing on one of the boxes. Then I walked back in and looked at the pad some more.

The guys were loading the boxes into the car. I walked thru the pad from one end to the other. The fireplace was still smoking. I walked back.

Shit I said shit. Oh shit.

I locked the door.

DEAD OF WINTER

How are things Ben said. He brushed the snow off his sweater and sat down on the couch.

I waved my hand at the pad. It was a good pad and it was warm.

Ben didn't say anything. How are things with you I said.

Fair said Ben. They've been better.

97

Oh I said.

I got out the cognac and poured it into two japanese tea cups. What's up I asked him.

Ben took his cognac. Fuzz he said fuzz is looking for me.

Oh I said oh man what a drag.

Like I can't go to my pad he said. Four of them.

I said oh again. Then I said shit.

The baby started crying. I picked her up. What do they want you for I asked him.

I don't know he said. Then he said like I don't think I'll go ask them.

The baby was heavy. I sat down and put her across my knees.

Ben said she's going to be a pretty kid.

Yes I said I think so. I just told her father about her I said.

Ben grinned at me then he said what did he say?

Like he said wow I said to Ben. He just said wow kind of.

Ben laughed. He drank the cognac and put the cup on the table.

Then he said you know any cool way out of the country.

No man I said I never did that.

He said yeah I know.

The baby was very bugged and I started walking back and forth with her on my shoulder. I'll ask around I said. I'll let you know.

He started eating some crackers on the table. I gotta cut he said. I gotta meet this chick. Like she's getting my clothes.

He looked tired. I said hey man you staying anyplace.

Yeah he said I gotta couple places. Then he said one of them's not so cool.

I looked at my pad how it was cool and then I looked at the baby. I said like man you can always stay here. I hoped to god he wouldn't.

THE END OF WINTER

Don came into the room and I woke up.

Hello I said. It was 1 AM.

Hello he said. He sat down on the bed and kissed me. Let me see her he said.

Sure I said. Then I said don't wake her up.

No he said no I won't wake her.
Wow he said. She looks just like my boy.

I got out of bed and put on a housecoat. Does she really look like Mark I asked him.

She really does he said. Her hair is darker. Then he said she really does.

What a gas I said. We'd better let them know about each other. Then I said how are things.

OK he said the same.

Oh I said no fellowship.

No he said.

You'll get one I said. Maybe you'll get one next semester.

Yeah he said. Then he said as long as you wanted her and you love her like who am I.

Wow man I said don't say anything.

We didn't say anything else. After a while I got up and got a blanket.

Then I said where you supposed to be.

Different places he said my wife thinks I'm with my folks.

I touched the line by his mouth. We got to tell the kids about each other I told him. Like man they might meet.

It was getting light.

Jesus he said. He laughed. As bad as the Greeks.

Yeah I said as bad as that.

More or Less Love Poems

1

Lullaby

Sleep lad
lie easy
now don't you moan
once every flip this world goes upside down
and we'll live in the cloisters
bye and bye

we'll hunt in the park
and keep swans on the lake
have a new year's party
at the frick museum

you'll write on parchment
between the lions
the Rembrandt room
will be our salon

> *no lights but torches*
> *bye and bye*

we'll put a mattress
among the Brancusi's
drink orange juice
from egyptian glass

> *just birds to see us*
> *bye and bye*

we'll give your ballet
at the plaza fountain
I'll jam till dawn
at the opera house

we'll tame the panther
and learn etruscan
and joust on broadway
in full dress armor

Honest lad
if you'll only lie still
we'll live in the cloisters
bye and bye

2

for you
i would no longer pick
my so-pickable nose
or bite my delicious nails

for you i would fix my teeth
and buy a mattress

for you
i'd kill my favorite roach
that lives in the woodwork
by the drawing table

3

if i comes here to live
will youse promise me
meat on sundays an a lil
grass
for a pillowsnooze
cheese in the icebox an a
tonguekiss between nightmares
ifn i comes

4

how many days
you think
i'll let you go
cool's not the word i'm after

i'll slip a diamond
underneath my tongue
and you
can hunt it down

5

take
what it's worth
my left
sixfingered hand
the stairs are shaky
knowing
you
walk up

6

a hundred maggots
taught my gut to squirm
a hundred weeks ago

and now you come with berries
in your hair
and wait for my
applause

7

I wonder
why
we slept
at all

those nights
and what we missed

8

you bet your life
next bedtime
I'll get even

I'll call your name wrong
and you'll think
it happened
accidental

9

Short Note on the Sparseness of the Language

wow man I said
when you tipped my chin and fed
on headlong spit my tongue's libation fluid

and wow I said when we hit the mattressrags
and wow was the dawn: we boiled the coffeegrounds
in an unkempt pot

wow man I said the day you put me down
(only the tone was different)
wow man oh wow I took my comb
and my two books and cut and that was that

10

SO BABE
WHO SEZ
IT'S COOL
TO CUT
JUST CAUSE
THE HOUSE BURNED DOWN?

11

Poems for Bret

I've caught you at it
mister
with your
I-Hate-You love poems.
I seen you
draw that
cyclops
on the wall.
You'd better watch your step
deari-o.
I seen your tricks
and babe
I've got my eye
on you.

You know
it's good
for once
not to be dug
because I know so much
or I'm so cool
or any
o-help
reasons

it's nice
to run a pad
where both of us
are cool enough
to know we're both
uncool

12

Requiem

I think
you'll find
a coffin
not so good
Baby-O.
They strap you in
pretty tight

I hear
it's cold
and worms and things
are there for selfish reasons

I think
you'll want
to turn
onto your side
your hair
won't like
to stay in place
forever
and your hands
won't like it
crossed
like that

I think
your lips
won't like it
by themselves

13

I hope
you go thru hell
tonight
beloved.
I hope
you choke to death
on lumps of stars
and by your bed a window
with frost
and moon on frost and
you want to scream
and can't
because
your woman is (I hope)
right there
asleep.

Baby I hope you never close your eyes
so two of us
can pick up on
this dawn.

14

no aperture of your body I do not know
no way into your gut I have not studied

so now
we pause for this finesse
silk at your temples
and
in the hollow of your neck
a tongue
goes gently

15

your tongue
explodes
like jailbreaks
in my head

16

damn you
lovely
you come and go
like rivers
which makes it hard
on rocks

17

In case you put me down I put you down
already, doll
I know the games you play.

In case you put me down I got it figured
how there are better mouths than yours
more swinging bodies
wilder scenes than this.

In case you put me down it won't help much.

18

they all say
you're lovely
but everytime I look
the sun
(or something else)
gets in my eyes

19

the word you whispered
turned your hair
to snakes
and that star
your face
went nearly
out

20

no babe
we'd never
swing together but
the syncopation
would be something wild

21

you are not quite
the air I breathe
thank god.

so go.

22

In your arms baby
I don't feel no
spring in winter
but I guess I can do
without
galoshes.

In your arms baby
I don't hear no
angels sing
but maybe I forget
to turn on
the phonograph.

23

you are my bread
and the hairline
noise
of my bones
you are almost
the sea

you are not stone
or molten sound
I think
you have no hands

this kind of bird flies backward
and this love
breaks on a windowpane
where no light talks

this is not time
for crossing tongues
(the sand here
never shifts)

I think
tomorrow
turned you with his toe
and you will
shine
and shine
unspent and underground

24

notice to all
land offices:
Investigate
New
Holdings

it is rumored
that the unicorns
have staked
a large
claim
in the Rocky Mountains

25

I don't forget things
fast enough, I sing
last summer's ballads
winter long

like that's uncool

Song at 24

time
has eaten my innocence like a pistachio nut
love has walked off with my trust

o noble firstlove
 all goonygreen
what did you do with my laugh
what did you do with the money I gave you fridays
and holes in my shoes?

Here with the lake for comfort
 would be swell
If I could figure how to make the rent
When I got back to town

Here with a brook and all that jazz
 I think of you
Who don't love me
 who don't love you
And ain't it cool baby?
So cool we chill our beers on it.

This here's no place to think of beer.
 All green.

28

Three Laments

alas
I believe
I might have become
a great writer
but
the chairs
in the library
were too hard

I have
the upper hand
but if I keep it
I'll lose the circulation
in one arm

So here I am the coolest in New York
what dont swing I dont push

In some Elysian field
by a big tree
I chew my pride
like cud.

29

but babe
if you saunter up here
with that
fresh-from-country
smile
and those hands
damn you

don't think
this time I won't ask
where's the ballet boy
you've been spending
the week
in town
with

30

The Life & Times of Monos

monos
they say
went mad

they say
a god
drew eyes
inside
his eyelids

they say
he couldn't sleep

monos
they say
built walls
around Olympus

they say
the walls
reached halfway
to the stars

the gods
are digging out

monos
they say
made war
upon Apollo

they say
he was
the first
to think
the furies
were
the muses

monos
they say
could never
have
a lover

they say
men turned to earth
who touched
his flesh

they say
he never
wept

31

Songs to Spring

spring
you're nice
you're a pretty season
please come soon
all green
and mushy
because
if you don't get here
I'll have to make
more fires
and the wood is getting
my hands
full
of
splinters

Dear Spring
with balmy
etc.
this is to inform you
that due
to your inexcusable
lateness
small fleabitten cats are dying
in hallways
all over
10th avenue

O dear
I perceive
by the numb
of
my
feet
that it is
fall or
winter
or some other
notspring season

how come is that?

Well spring
I'm onto your tricks
don't think
I'll be easier on you
because
all winter
you sat on a fence
and grinned
spring
when you come again
I think
I'll never sleep
for walking the
2 AM mist
till dawn
and then
dancing the day

Songs for Babio, Unborn

Body
whose flesh
has crossed my will?
Which night
common or blest
shapes now
to walk the earth?

Body
whose hands
broke ground
for that thrusting head?
in the eyes
budding to sight
who will I read?

Body
secret in you
sprang this cry of flesh

Now tell the tale

Sweetheart
when you break thru
you'll find
a poet here
not quite what one would choose.

I won't promise
you'll never go hungry
or that you won't be sad
on this gutted
breaking
globe
but I can show you
baby
enough to love
to break your heart
forever

Some Early Prose

Untitled

They speak of it as of a golden age, and there are many who do not believe the tale. They say that in those days, all men were made alike. Their limbs were the same in number and molded in the same shape, and they walked upright upon two of them. There are some who say that almost all of them could see and speak, and that their skin was whole and no part of their body wrinkled and twisted from birth.

There are many who do not understand these things. In my country each child is examined at birth for the weak, gnarled places in his body that will be of no use to him. There are some that are completely twisted and useless and these are left to die.

When I was a youth I could not understand this law. I wept over my newborn sister, and fought the wolves from her. Finally I became exhausted and slept and they of my village came softly and carried me home. When I awoke my father looked sadly at me and spoke, and I bowed my head and accepted the laws and the bitter ways of my tribe.

For my father compelled me to understand that these laws are necessary if the tribe is to remain. We care for the partly blind ones, for the lame, and for many who cannot speak, but those who will be able to do nothing must die. It is the only way.

It was then that my father told me of the legend. He said that the elders had heard of a time when all the men were straight, and the women good to look upon. It was not like today when the leaders of the tribe are those who can speak and hear the spoken word and see besides. In those days all men could do these things. And all the earth could bear crops, my father said. There was no Black Ground to bring death to those who walk on it, and doomed children to those who come too near.

These beautiful ones grew in strength and understanding. They called our Black Ground Mother Earth and crossed the Great Sea. They understood all things, even to the distance of the white stars. But, I do not understand how

it was, they became afraid. And the leaders took council together and destroyed all the beautiful people. And the earth became the Black Ground, and those who survived the great destruction came forth from the caves and the sewers and bore children. And the infants were twisted and strange to look upon, and many died.

And now there is a tribal law to compel us to bear children, though most of them feed the wolves. We are very weary, and mating is not a joy to us. But my father says that the tribe must go on, for we are different from the other animals: some of us speak, and that is a gift of the gods.

April, 1953

DAUGHTERS OF EVENING:
Scenario for a Proposed Movie

1.

A flamboyantly bohemian street, at dusk. A young girl with short, tousled hair is walking rapidly. She wears Levis and a heavy navy sweater. A crowd of sailors, obviously on leave, watch her pass with evident amusement. They shout after her and one of them reaches out as if to grab her.

"Oh Baby. . ."

"Give it to me now."

Etc.

She avoids them without breaking the rhythm of her walk and goes on. The darkness has already cut her off from them when she hears another wave of comment. She turns and sees a rather beautiful woman with long black hair walking through the mist. The woman moves as if sleepwalking. Her face is neither calm nor indifferent: it is merely oblivious. She is unconscious. The girl steps aside to let her pass—stands looking after her—and then turns and goes up a flight of stairs into one of the dim bars that line the street.

2.

The interior of a Village bar. There are two rows of tables against the walls with a jukebox between them at the far end of the room. The benches are covered with cheap, torn plastic. The pictures on the walls are crudely done in black and red chalk. They all represent gaunt, obviously homosexual women in attitudes ranging from pride to despair. The pictures are technically awkward, but they convey intensity and bitter conviction. The walls of the room are rose, the lighting orange and fluorescent, the atmosphere soft and very dense. The jukebox casts a pale blue stain on the bare wood floor: an oasis of hunger in the pink oblivion. Here is the common removed from the commonplace by acquiring the dream status of a place inhabited by outlaws.

Two girls are mambo-ing in the back of the room. The butch is heavy and slow, her clipped hair is in poor accord with her round, blurred face. The femme is gaunt and pinched looking. Her blond hair lies flat along the

sides of her face and ends above her shoulders. She moves with a quick, tensioned weariness and does not take her eyes from the other's face. They both wear the white blouses and straight skirts of office girls, and neither of them speaks.

The young girl enters. She is wearing a full dancing skirt and red satin ballet slippers. Her hair is long and there is a scarlet sash around her waist. She sits at a table in the front of the room and watches the dancers. A dapper young butch with smooth platinum hair comes to the table and sits opposite her.

The music has changed tempo. The dancers, now wearing close-tapered dungarees, hardly move at all. Their arms hang at their sides, and their bodies cling together and move loose in easy intimacy.

At a table in the back, an arrogantly handsome negro man sits cradling in his arms a doll made of knotted towels. He is weeping without making any attempt to cover his face. He is as naked as the dancers; even more absorbed in the sensuality of his passion.

The music ends, and the dancers stand still without drawing apart. The man unknots the towels and wipes his face which is covered with tears.

3.

An oval room, dazzlingly white. At the narrow end there is a ledge made of plaster on which the woman with long black hair is lying asleep. A white cloth which seems to grow out of the ledge covers her body.

The girl, dressed as in the first scene, enters through a door on the far end of the room. She does not notice the woman. She is completely at home in the room, and states by her movements that this is a very familiar place. She throws a jacket on the floor and stands extracting something from a pocket of her jeans. Then, with a sigh of content, she throws herself full-length on the floor and begins to write in a small notebook.

4.

An open plateau. Mist. The girl now in leotard and dancing tights, with a long tan sash. A tall boy with a strong sad face who wears Levis and a white shirt. The effect should be very vivid.

They dance. The dance is a mixture of swashbuckling, mischievous

pride and sudden strains of lyricism.

While they are dancing the mists lift slightly and reveal a cliff in the distance with the woman still asleep, in the same position as the last scene.

The scene brightens gradually and dies out in blinding light.

5.

The same set as scene one. It is night. The girl emerges from the bar. She is dressed as she was in scene two. It is raining very hard. The girl descends the steps very slowly, she is looking for someone. She joins the boy in Levis who is waiting under the canopy at the foot of the stairs. They join hands and walk off together down the street.

They reach a darker stretch of sidewalk, one of those factory districts with cobblestoned streets. The rain has stopped but the streets are still wet. There is a bonfire in the distance. They are talking intensely and do not notice a long wooden black box which they pass. He says "That was a coffin." The sound of his voice is very startling, for the soundtrack has held nothing but sound effects and music this far. They go back, hand in hand, to look at it. On the lid sit two small, gnarled creatures playing chess.

6.

A large, bare, square-ish, grey room. In the center the nude figure of a woman, which revolves slowly. From the four corners of the room, a slow procession gowned and hooded like monks advances toward the center of the room. The nude figure revolves faster and faster, until it is a blur of whirling light.

The monks approach the spinning figure with a ritualistic, hesitating walk, and disappear one by one as they step inside the periphery of light .

7.

A large studio apartment in the village. Early morning is indicated by the slant of the sun, and the lack of noise from the street below. The girl lies asleep in a large bed by the windows. She is naked, and wears on one wrist a heavy silver bracelet which the boy had worn the night before.

The boy, fully clothed, crouches in the center of the room. His hair is disheveled, but otherwise he looks exactly the same as the night before. He

is talking into the microphone of a tape recorder whose light flashes on and off rapidly, competing with the morning sun. He is heard saying "A coffin stood on the sidewalk" as the scene fades . . .

. . . .

(Unfinished) 1953

THE DARK IS DARK ENOUGH

He walked home through the unbearable city heat, through streets reeking of food and filthy clothing. Turned automatically at the corner where the smell of embalming fluid from a funeral parlor met abruptly with the beer smell of a corner bar full of factory workers. Walked a few steps and stopped at the first house after the smell of salted fat from a sausage manufacturer, the sidewalk greasy and covered with sawdust.

Without stopping he opened the mailbox, scooped out a housekey and a letter. Climbed the stairs to the news that Bell Telephone was turning his bill over to a collection agency. On the stairs avoided spilled garbage, cat shit, and an unsteady child.

Key in the mailbox meant no one was home, and he swung the door open, letting the cool relief of an evening's solitude fill him. Automatically he reached for the light switch and clicked it twice before he remembered that the lights had been turned off. Fumbled around on the table by the door for the flashlight, found it, and walked by its swinging light to the bed. With slow care, savoring every action, he sat down, unlaced his shoes, and hurled them against the far wall of the apartment. The noise they made was satisfactorily dull—he hated racket. Then he swung the flashlight along the floor till he located his sandals and lined them up beside him while he tore off clinging socks with no toes at all and slipped his steamy feet against the cool, worn leather.

This ritual over, he took off his clothes, hung the pants with care for the crease over the back of an overburdened chair, and pulled on Levis and a tee shirt.

He stretched on the bed for a minute and played the flashlight over the ceiling where the cracks made pictures. A long-legged girl with one arm played with her hair, and a rabbit with three ears sprang out of the dirt-streaked corner. Tiredness abating, hunger swung the balance, and he traced an arc with airy legs and see-sawed to a stand.

He dropped the flashlight which went out and rolled under the bed, leaving him the dark. Walked the four steps to the table where neither matches nor candles were. Then he returned to the bed and groped under it, finding only a handful of dust and the squeaks of disturbed mice. Finally he found one candle and some matches at the upright piano in the closet which served as an extra half room. Angry now at the dark, he lit candles by braille, encountered in the half-light a leisurely roach and gave chase. The roach with fine instinct chose the darkest corner. He stubbed his toe on an overturned orange crate of books, cursed, and managed to obliterate with hot wax half a line of a Three Part Invention.

He returned to the larger room with wax-covered, scalded fingers and stepped on something soft which screamed. It then took him fifteen minutes to chase, catch and eject the neighbor's cat.

With the help of one candle, he located and lit the others and threw the room into the suggestively dim glow of an after-hours bar. And set about getting supper. Until he discovered that the floor was covered with coffee grounds from the garbage bag which the cat must have upset. . .

He counted his week's pay and decided that if he didn't go out this weekend he could eat out tonight and still have carfare and enough to pay Con Edison and cover a wash at the laundromat.

Relieved, he found his keys, blew out the candles and left. Stopped at the hall jon which reeked of a catbox. Sat quietly, trying to make peace with the dirt and the heat, humming "Squailaaar and Povertreeee" under his breath to a once-popular tune. Confusion in abeyance, he sat shitting, fingered his money, and thought about turning on the lights again. Then he discovered by reaching around in the dark that there was no toilet paper.

Anger, rejustified, came back in a flood. Cursing again, he reached in his pocket, selected the softest ten dollar bills, wiped himself with them, flushed the toilet, and went out.

1956

138

ANOTHER SHORT STORY

The cat lay in bed and listened to the rain. It came down faster and then the heat came up. So he listened to the pipes knocking and the rain stopped and then there was the hissing sound in the radiator and it got light.

The cat lay in bed and listened to the floor crack like knuckles and then the women put out the clothes and the clotheslines made it in rhythm real mad and then steps on the stairs and doors banging and then it got dark.

The cat lay in bed and listened and he heard windows shutting and beds being pulled out and then he heard nothing. It was dark for a long time.

The cat got out of bed and went to the phone. At the tone said the woman the time will be one fifty five and thirty seconds. Beep. The cat leaned back in the chair and started to doodle on a piece of paper. He kept the receiver at his ear.

The cat uncrossed his legs and grinned. At the tone said the woman the time will be five twenty five and forty seconds. Beep. Yeah said the cat. It was good to talk to somebody. He put down the phone and went to bed.

1954

THE VERY HAPPY COUPLE

Once upon a time there was a very happy couple. They used to go on dates every weekend and then they would kiss each other goodnight and turn their backs on each other and go home.

One night when they kissed something strange happened. But they pretended not to notice and turned their backs on each other and went home.

This went on for some time and they decided to get married.

On their wedding night they found themselves in a room with a double bed. So they turned their backs on each other and took off all their clothes.

They got into the double bed and after a while they figured out what it was they wanted to do. So they turned their backs on each other and put on contraceptives.

After they got through doing what they wanted to do, they both felt unpleasant. So they turned their backs on each other and cleaned up.

They got back into bed and looked at each other but it didn't seem like there was anything to say. So they turned their backs on each other and went to sleep.

1954

Little Nightmares After Kafka

1.

It is Sunday and I have just eaten brunch. I go to the park to hear the folksingers. Many people with instruments pass but they disperse. No music is heard. Is the permit for one o'clock or two o'clock. I cannot remember. I take a cab to City Hall and examine the records. There is no mention of a permit. I return to the park in time to see the folksingers putting their instruments away. The permit was from 1:55 to 2:00. I examine it closely and discover that it is located in Department XDY at the Hall of Records. I take a cab and return to City Hall.

2.

They're fixing the sidewalks with cardboard they really are. Only this morning I saw them stuff a hole with cardboard and cover it with sand. All those fellows looking real cool and sly like, smoothing out the cardboard with shovels. With those orange "Dig We Must" signs all over the place.

Yeah man I'm hip.

That sort of thing is dangerous, it might be paper next, rags anything. Lucky thing this isn't Frisco, I can see how it would look after a quake with old nightgowns popping through the sidewalk. And the old newspapers:

> 15 MILLION TON
> HELLDROP BOMB
> LIKE 500 SUNS

Like man, that's the stuff you gotta watch.

3.

Three days ago they dropped the bomb and today it rained. If my head was a geiger counter and I was a chicken I'd have clucked my way to a hundred eggs in the beat of that rain. But as it is all I did was sing goodbye to my genes and start on a series of nursery rhymes for eyeless or three headed children. Nothing I did seemed to comprise the full gravity of the situation, so I locked my shadow in the oven because she was threatening suicide.

The trouble is there's a full moon tonight and I hate to think what will happen if she gets loose.

1954

THE MOBILE

He walked the blind cubicle of the room twice, and sat on the bed, his head in his hands. He could think of nothing except that his pose was overdone. He became sick at himself for this thought—it seemed to him that no one sincerely upset would consider how he looked while sitting on a bed in an empty, filthy room. "And what if it were a public stadium?" he almost shouted, thoroughly revolted. "I should still have no cause—" And to display his contempt for appearances, he flung himself face downward on the bed. A slow shudder passed through him, and he turned on his side and lay still. "But this is repugnant," he thought, "and how long has it gone on? This constant, ridiculous warfare with an invisible something that sees and sees through. This objective third eye—detached, quite detached from me—and yet made of the same white porousness that forms the deepest, most essential I—Eye I how sedie is it porous tha e I madonna—reasonness this noteworthy—"

He fell asleep and was immediately aware of a series of glass objects glinting and tinkling on a spiral wire that was gyrating fantastically in the air above a singularly calm, and somehow sinister, lake. But the lake was simply a pane of glass painted black on the underside. The objects were many-colored and of weird, very definite angular shapes, and they were each attached to the wire by a hole in a corner.

He stood still, fascinated by this sarabande of geometries glittering in the sun. Slowly, irresistibly, he was compelled to look at the sun. He fought the impulse, but even as he did so his eyes found it. It was slightly declined to the west and singularly white. Then a dark, curving line crept across the sphere. It fluctuated, widened—and he screamed aloud for he was looking into an eye.

Everything was covered now with that incredible darkness which comes with a total eclipse—everything except the mobile which flaunted its lightning over the lake, the black mirror, and to this the eye turned.

He watched. A single yellow ray of some substance denser than light

emanated from the center of the eye and focused on a diamond-shaped piece of green glass— The light dripped slowly from the diamond, reaching pale green fingers into the mirror and fastening there in a blotch of color. The once-green glass softened and rounded to an indefinite brown-stained oval. The eye moved on to a blue cube.

He thought it would go on forever, the insatiable mirror becoming splotched with colors. But the spiral caught itself up, and began turning and writhing in earnest, followed—forever followed—by the line of that sucking yellow ray. It began turning on itself, smaller—and tighter. . .

They called it death by suffocation. He was tangled in the blankets—in a many-colored quilt that none of his friends had ever seen before. It was so knotted that they had to cut it away from his body.

1953

Tale For A Unicorn

Once upon a time, in a horrible city, lived a poet and a unicorn. They had been friends for a very long time.

Now to understand about poets and unicorns, you must know that they belong to the myth kingdom, which is different from the animal kingdom. All the creatures in the myth kingdom can see each other even when they are invisible to other species and this makes them very attached to each other.

Now the poet was a very nice poet, and she made coffee, and ate little pills, and always welcomed unicorns and other mythical creatures, as a poet should. However, she had one very unpoetical fault which made unicorns very unhappy. The poet got Kinks.

This was because she didn't sleep very much. Sometimes she got a Kink in her knee, or her finger, and that wasn't so bad; in fact the unicorn didn't even mind when she got a Kink in her neck; but once in a while she got a Kink in her brain, and this made the unicorn very sad indeed, for he did not know how to cope with such a Kink, nor did he want to, especially.

(If you have ever seen a poet with a Kink in her brain, you will understand how the unicorn felt. A Kink in a poet's brain is not a thing one knows how to cope with.)

Now, one night as they were riding in a car with some other members of the myth and the animal kingdoms, the poet, who was very tired indeed, got a Kink in her brain about the unicorn's friends. Actually, the unicorn's friends were mostly very nice, except for the fact that many of them were hybrids, and belonged partly to the animal and partly to the myth kingdom. Such creatures have a habit of appearing and disappearing in the outside world in a most flippante manner, and this annoyed the poet, who like all poets thought that the mythical game of secret recognition was very sacred and not to be tampered with.

145

(Poets have such quirks and mostly they take far too many things seriously and far too many things lightly and always all the wrong things.)

Anyway, on this particular night, as they were riding from the Land of Safety, which they called Home, to the ancient Land of Adventure, which had been laid waste in the long war between the animal and myth kingdoms, and which still bore the archaic name of Greenwich Village, the poet, who had a very large Kink in her brain, began to tease and berate the unicorn about his hybrid friends and one in particular which they were to meet that very evening.

Now unicorns, whatever their faults, are very loyal creatures, and the unicorn in question grew first very hurt and then very angry as he heard one of his friends berate another. As he grew angrier he began to look straight ahead and carry his head very high, and the muscle in his jaw stood out, which is a sure sign in a unicorn that he is Very Angry Indeed.

However, the poet, who had an extraordinarily large Kink, told herself that she didn't care and when they all got out of the car she clomped away down a street with that peculiar clomp which is a distinguishing mark of poets.

And the unicorn, lifting his head higher than ever, leaped away into the night.

And many hours later when the poet got home, with the Kink no longer in her brain, she was very sad and sorry and she felt very foolish. She tried to think how to apologize to the unicorn, but she knew that poets were proud and unicorns were proud and that apologies just wouldn't do at all.

And so she wrote this tale.

1955

THE TROUBLE WITH UNICORNS

"O unicorns are all right," the poet said to herself, as she tried to construct the ultimate vacuum out of the fifth dimension and an allegory.

"O my yes unicorns are *fine,*" she repeated, packing aspirin into a hole in her tooth. "What I mean is they're so decorative and all. They're very sensitive too. Yes, that they are, they're *sensitive.*"

(The poet never thought of words like sensitive unless she was Very Bugged.)

"What's wrong with them," she said, "is how they Amble. You never know," she said, "when they'll turn Up. Or how."

"*Why* is easy," she went on. "Mostly they turn Up because they're hungry, or they forgot where they were going. But How and When you just never know."

The poet sighed. She chewed the skin off her left index finger and ate some pills.

"This one particular unicorn," she said. "Ask him to dinner he'll turn Up for breakfast. Not even the same week."

"No reason," she said. "He just does. Ambled probably. Ambles at the slightest excuse." She gave a pepsi to a troll who was sneezing in the corner.

"It's very interesting" she said, "what is an Excuse for a unicorn. Grasshoppers. Stampedes. Matchbooks. Any little distraction."

"Meanwhile," she said, "poets starve to death Waiting." She shook her fist and two roaches ran back under the sofa.

1955

What Do Frogs Say?

Now there's a question. I was sitting on the couch. Waiting. For food to cook. For the wash to finish. For Zella. I had been doing laundry all week. Finish one wash and start another. There was no more room on the clothesline. But there was more wash. So I did it. The food was tomato sauce. I can make a swinging tomato sauce. With spices. Basil. Oregano. Parsley. Red Pepper. Thyme. I love the smell of spices. They smell clean. Not like the city. Clean. I was at the Cloisters once when they were setting out herbs in the gardens. The inside of the shack where they kept them was clean and old, with drying herbs hanging in bunches near the ceiling. Not at all like Manhattan. No roaches for one thing. Just this lovely old dyke, happy, setting out herbs, and the clean air cold and the Jersey cliffs, purple and far away. That's how spices smell to me. Especially oregano. I do love that one. Freddie says it's cause I'm a wop.

Freddie was painting. Not too well. He was painting green and he doesn't like green. I don't think he understands it. He understands orange all right, but not green. Green is cheaper though, and we have no money. So he was painting green. The green was left over. I said to him What do frogs say.

Jeanne has this picture book. She doesn't really know what it's all about, but you point to things, and make noises, and she digs it. Gets you in trouble, though. Like with butterflies. What the hell do butterflies say? Nothing. So I moved my hands around like flying and she was happy. I could smell the sauce even from in here. It smelled done. And Zella wasn't here. I figured Freddie must be starving by this time. I came on like the sauce wasn't done, because Freddie was starving. And not too happy. I figured he didn't want to wait for Zella. But I did. I turned the page and there were these frogs. I pointed to them. Jeannie waited. I've never seen a frog. Never. Very peculiar life I've had. Seen an albino roach once. But no frogs. I said to Freddie What do frogs say.

He didn't say anything. He just kept on painting. He'd been very sad for a whole week. He never listened. Even less when he was sad he listened. There was this phonecall he got which made him sadder. And spring. So he

didn't listen and he didn't say anything. I waited. Jeanne looked at me and waited too. Then he stopped the green and started on black. I said to him What do frogs say.

He made this awful noise.

Is that what they say I asked him. That's too loud. Jeanne liked it though. They can't possibly say that I told him. They're too small. Freddie started on white. I heard a knock on the door but nobody was there. I gave up and put the spaghetti in the water anyway.

That's what they say said Freddie. There is no logic in frogs. He made the noise again.

1958

Music Journal

They're playing *The Messiah* on the phonograph, and it still reminds me of Lori. They say that when every street in a city reminds you of something or other in your life it's time to move. . . I guess when every important piece of music reminds you of something or someone, it's time to die. It hasn't come to that yet.

The Messiah—Lori, at the piano on East Fifth Street, banging out the chords and singing, all sinew and tremor, her unspeakably sexy, unspeakably terrified mouth, and those hands. It seemed always as if every muscle and tendon in her body had a life of its own. Kissing her small back.

The B Minor Mass—making it in the afternoon with Buck Dunbar who was twice my age. How his hands did shake sometimes when he touched me, and how I was deliberately trying out the knife edges of all my possible bitchiness. The needle going on and on in the groove at the end of the record, and no one turning it off.

The Brahms Requiem—Lori in her room (almost I said cell, it almost was one) at Swarthmore. That pathetically little, pathetically and bravely tasteful room, with the fine hi-fi, the worn, dowdy clothes from Lord and Taylor, the Picasso print. The wrought iron chairs—calling sling chairs "African camp chairs" I remember was one of her habits. Sitting there, after the whole thing with Swarthmore had crashed, sitting there and finally giving up. My battered attempt to put some life back. The Brahms Requiem. Her innumerable calls to Nancy. People at the door. Finally my fleeing, saying to excuse it, "She wants some privacy", then finding the note pinned to the door as if with a thrown knife: "Where the hell are you, DiPrima?" and the girl gone.

The B Minor Mass—at Boo's, the estate in Massachusetts that her family had—almost, it was an estate. The goddamned sunset on the lawn in back of the old revolutionary inn that was their house. The "negro caretaker" and his wife giving us supper. We had moved the hi-fi outside and the Mass blared out across the lake, the herons weren't impressed, they stood still and the sun set behind them.

Fidelio—Mephi sitting in the old music library, where you wore earphones and they had only 78s and you sat there with earphones on, staring out at the brick wall across from the library and listened, and sometimes you wrote and Mephi hearing Fidelio there, the "Ach! was dunkel hier!" and beating on the wood table, her knuckles white, which was I suppose adolescence.

King Arthur—"Let me freeze again", our favorite suicide music. Mephi and Lori on the double bed at Cornelia's, talking in some sophisticated code that completely escaped me, yet doing it only for my benefit, a language demonstration. That horrible ginger beer that Cornelia thought was the proper thing to offer girls just out of high school before you seduced them. Mephi singing Dido in her husky voice. Alice Borden who looked like a rabbit. Kissing her in Abingdon Square and putting her into a taxi. Then going into the White Horse Tavern where they were still talking about Dylan Thomas. The hot spiced wine there, the foolish knockwurst sandwiches. Going back there, years later, with Bret, the last place almost I ever went with Bret, and talking my head off about the Jones household, one month before it was to join me in some abominable trek which isn't quite over.

Oh, there's still plenty that doesn't mean anything. That way, at least. *The St. John Passion.* Scriabin. Altogether. No, that's not true. Some Scriabin or other, on terrible scratchy 78s at Amsterdam Avenue. Freddie lovingly bringing the 78s all the way from Ossining so we could hear them. We, O'Malley and me, being so far behind him that we could only look for Form and not find it, and be bewildered. But something else must have happened, because I remember that music and not for its formlessness. Then the early Miles was happening. *Walkin'* and *Solar*, and the MJQ was still exciting a little; the first side of *Django* they did. . . Hearing it at Billy James' house, four a.m., his wife having bitched herself to sleep bugged because tomorrow he was supposed to job hunt, and me and O'Malley sat there, keeping him up, reading *The Once and Future King* to each other, the part about the owl and hearing *Django*. His funny elf face. The blue dawn light in those windows. In so damned many windows.

Especially I remember it in the windows of furnished rooms where it hath a peculiar beauty. On rickety roachy bookcases where you have put three or

four forlorn volumes and a notebook, on the chintz slip covers, dirty where head and ass and arms rest, on the bed, like as not stuffed with bedbugs instead of mattress stuffing. . . there was sometimes even a picture on the wall. A cottage with flowers from the five and ten. Or the dawn that found me crying in a midtown hotel, because Lori had kissed me on the mouth and then stopped and nothing had happened, I lay there thinking because she could tell from the kiss, tell I'd never been kissed on the mouth before and so she didn't want me. But how beautiful it was in that midtown hotel, because there was a bathroom, it was all ours and we took hot baths for hours, three dollars a night.

Or the Puccini we loved much earlier on a salty floor in Brooklyn, listening, again those old 78s, how much one loved records then! They were so heavy and cumbersome to play and they stopped so soon. The little momma of the house in her ugly aprons, making us sandwiches. And all of us, stretched on the floor, hands over our eyes, hearing again *Butterfly*, and smelling the sea only blocks away. Our walks to the sea, punctuated with the boats in Sheepshead Bay, with a bronze statue of Byron on the lawn of an old maid's house, the rocks along the esplanade and that small brown-covered Keats I always carried, with margins in red drawn all around each page and flowers embossed on the cover. How it fell apart from sleeping under my pillow. One of the first irreparable wrongs I did was to throw it away.

Forgiveness is strange, and comes unexpectedly. In San Francisco last year I found another Keats almost as small and carriable, bound in blue leather and bought it. Someday, too, I'll find another opal.

The piece of forgiveness I've just purchased, like a plenary indulgence, some can be bought, sleeps in the next room, after supper.

Forgiveness through change. The passing seasons.

Playing the *Sonatas and Interludes* of John Cage on Houston Street and Roi: "They're playing our song" laughter. All to the good. The hearing Ornette those tense nights of last summer after having hidden Alex Trocchi, after having worked in that dusty bookstore, after having pot and putting off Larry,

and yes, the morning after I did finally sleep with him, the dawn light then, walking across the city on Houston Street, the buildings half-wrecked and with pigeons still living in them. Hearing them coo and thinking the wrecking ball that swings so slowly now would tomorrow kill them. As the wall tottered and the cooing grew still. In the clear air of the morning, that wall jutting up, a field of broken bricks, the sounds of the pigeons. Then going to church, hearing dawn mass, the old women, the young whores still not to bed. The smell of Prince Matchabelli, Blue Grass, other cheap perfumes, the old ones in black, black scarves, the young with high color still on their cheeks. Two sides of one coin. Receiving communion together.

Walking out again, and down the stone steps after. The peace of the morning, the stores beginning to open. The smell of the cheese hanging there so fine. Understanding homesickness is not for where you have been but for where you will never go, where the cheeses are hanging, the children playing in mud. A goat maybe tethered beside the house. Understanding that order, that universe better than this.

The whirlwinds of love, hashish and love, that made the rest of that summer. Billie Holiday, *Willow Weep for Me*, was the music of that. You had only to blink your eyes to see the whirlpool in which you were turning, slowly, your toes to the sky.

1960

A Couple Of Weekends

we were working for some kind of publicity man, when somebody asked us if we wanted to go to a jam session. actually, i was the one who was working, lynn olsen just sat on the couch and knitted afghan squares. she sat with her legs crossed and her toes sticking out of her sneakers, and we both looked very tough and inseparable and nobody ever asked me what she was doing there.

it wasn't a bad place to work, there was a goldfish pond in the floor, and all i had to do was mix martinis and address christmas cards. this was during a coldwave so we closed up our coldwater flat, and the people sent out for food and we slept on the couches. and in between working and sleeping i'd lie on the floor and watch the goldfish and think of how warm i was. the people who came there were very peculiar, a lot of investors and showgirls and a couple of stars who i never recognized, and they kept giving us tickets and five dollar bills and telling us to take a cab home and change before we went to the theater, and of course we never had anything to change into and so we would pocket the five and go in our jeans, me with a red crewcut and lynn in a navy jacket with holes in her sneakers. they bugged a lot of people, the holes in lynn's sneakers, it was a snowy winter, a very bad winter, and we would go tramping around and then go to work, and there would lynn's toes be, rosy from the snow.

it got so they started saying all sorts of things, like that johnnie didn't pay me enough to buy shoes for my girl, and that got them very upset because they liked to think of themselves as very nice guys and they were, when it came to money, they could afford to be, they lived off moviestars and i think all kinds of blackmail, i was never sure. anyway there were always these handy pocket wire recorders about, and the intercom was rigged. and one day i heard johnnie saying on the phone how much was so-and-so paying for blondes this week, and was he sleeping with all of them, and well, he had something for him. so they very much needed to think of themselves as good guys and they teased and bugged johnnie about what was he paying me, until the poor guy gave lynn twenty bucks and asked her to please get

some shoes. and the next day she came in in her sneakers and she had a package and she announced, well, i got shoes, and when everyone crowded around she opened the bag and pulled out a pair of engineer boots with brass buckles and looked very proud and everyone groaned and johnnie went to bed.

he stayed in bed a lot, while all his guests got drunk, and he listened to them over the rigged intercom system.

it was one of the guys who was worried about the shoes who asked us if we wanted to go to this session. he hung around johnnie's almost every night because he was in love with a girl who hung around johnnie's. her name was julie. she wanted to act or something, she couldn't dance, she couldn't sing, she couldn't act, and she wasn't sexy, so everybody figured she might really make it. also she was dumb. she was madly in love with this gay movie star who had asked her out once, and she never gave marty a tumble. but he bought her all her clothes and paid her rent, and sat there every night while she raved about this gay star, and there was luckily nothing heroic about him because he grumbled all the time about all of it. he told anybody who'd listen how much it cost, the coat, the rent, the dresses, and all the rest, and in between telling he drank a lot of martinis, but he mixed them himself so i didn't really mind.

when we got to the session it was friday night and nobody was playing. they had all stopped to drink and i think to turn on but they did that someplace else and didn't invite us. after a while they started and it was like all young white jazz of the early fifties with just the trappings of bebop and nothing happening. but we liked just being there, and watching the people, and we sat and listened or talked and drank tumblers of gin. when it got to be light some people went to sleep. we went to sleep around noon on saturday and when we got up there was still the music. a girl had come who sang and she was singing, and there was a new guy playing alto sax.

she was a beautifully built little redhead very slim in black slacks and she had a good voice. the guys dug her, and they were playing better than before. the guy on sax looked maybe fourteen and he had the same face as that photograph of rimbaud, no, not the same face but the same

155

expression. long beautiful hands with the nails chewed to hell. he played like something was happening and sometimes it was. they stopped on sunday morning around eleven, and we went out and walked and had some kind of breakfast.

we went to a lot of sessions and sometimes they showed up. the girl's name i found out was frankie and she was hung up on a drummer who sometimes came down. the drummer's name was tom and he lived in queens. in queens he was married and he worked all week, but the sessions were in manhattan and that was something else. he was sexy in that heavy, slow way that always bores me. frankie thought he was the greatest thing on earth.

the guy with the sax was named billie and tom the drummer was practically his best friend in the world. he wasn't fourteen like he looked, but seventeen, anyway that's what he said, i was never sure. turned out he was crazy about frankie but you would never have guessed it, he was so sad and touched and shy about everything that one thing more or less didn't add very much.

we went to a lot of sessions and then we stopped. they were all in the month of december, things have a way of dividing themselves into months, as if months weren't arbitrary, and i guess in a way they aren't. at the end of december i stopped working for johnnie, the gangster types started outnumbering the investor types and the showgirls, and they the gangsters just stood around and looked menacing which felt very menacing and probably was and there was too much traffic with wire recorders back and forth to some private detective's office. it was me who was all the traffic and i didn't like it. then cliff callanan came to live with lynn olsen everyone thought that she was living with me and she was, only cliff came to live with her which confused the people who knew it, not all of them did. we opened the coldwater flat and we lived there again. at the same time the sessions stopped they just did and we lost sight of them, of billie and frankie and tom the drummer from queens.

then the weather changed and everything changed again, i started living in the park with books all day and we all three mostly stayed up all night which

is the easiest thing to do when three people live together and two of them with one of them more or less.

a long time later it must have been in the fall i went into a bar where i never go and there was billie. he told me that his cat had just had kittens, in a drawer of his dresser, he said, and she was so considerate, she hadn't made any mess just one spot of blood and that on a very old sweater. the kittens he said were so beautiful. they gave him incentive and a sense of responsibility. he wanted to see that they had a good start in the world.

and so gradually i discovered that he was living with frankie, and they had a big apartment uptown and why didn't we come and see them? we did. it was huge and like a barn with no furniture and billie and frankie and the cat and all the kittens chased each other and themselves around it all the time, the kittens were very excited, billie and frankie were a little excited but the cat wasn't at all she just did it and looked detached, there were all these wrestling matches on the bed and the floor. we just sat and looked and then we had supper with them.

after supper billie went out for something and frankie started talking to us, to me and lynn, cliff had gone away in the spring, living in threes was making him very tired and he got too skinny and went to the west coast, which is mostly what people do when they get too skinny. frankie started telling us how it was, living with billie, girls nearly always do tell how it is and especially to other girls. she said when they both came back from their summer jobs they were sleeping together, they found this apartment and lived in it with the cat, and after about a month tom the drummer came back from his summer job. frankie was still in love with tom the drummer. now tom had noplace to stay except with his wife which didn't count i guess and after all since billie was his best friend and frankie was still in love with him what could be more natural than that he should move in with them. anyway he did. so there he was, the first day he came with his suitcases frankie says was a great shock to her. but anyway he was there and she started making supper and tom started taking a shower and billie sat in the kitchen looking gloomy. it was when she was frying hamburgers she says it came over her in a rush and she ran into the bathroom and threw her arms around tom

in the shower and told him she loved him she never loved anyone else. after a while it was wet she went back to the kitchen and billie was sitting so still it did something funny to her it really did and she thought about him and the cat and their apartment and she all wet began kissing billie and told him she loved him but even then he didn't say anything much. but after a while she thought about tom again and she had to go back to the shower to talk to him at least or to look at him. this went on, the hamburgers burnt, billie went for a walk, and after a few days tom moved out again.

we sat there making all the sympathizing noises, girls really do know how it is, that kind of thing, and maybe men do too, i never found out. anyway billie came back and we naturally talked about something else and it got dark in the wonderful way it does in big apartments and after a while we went home.

they promised to come and see us but they never did, and after a while fall turned into winter, a different kind of winter, and one day i heard of a session somewhere and i went. billie was there, not frankie or tom, i didn't ask him about them, and there was a very swish junkie who talked to billie a lot. they played a little not as much as they used to it was a one night session and by three in the morning everyone went to sleep. so billie and i started talking he told me he was in love with this junkie he wanted to save him. he wasn't living with frankie, we didn't talk about that, some time around dawn we made love on the floor of the loft, and we were both terribly sad. later i got dressed and went uptown went home, i slept a long time and i've never again seen any one of them.

but i heard through someone that billie had gotten hooked, the junkie had left him, he'd gone back home to the bronx to live with his family. i heard too that frankie had married somebody rich and was living uptown along fifth avenue somewhere and that billie had gone to see her but she wouldn't see him. she had the butler or somebody throw him out. i never heard what became of tom the drummer.

1961